8-08

willor

TRADE MARKS AND LOGOS

Trade-mark (R)

TRADE MARKS AND LOGOS John Murphy and Michael Rowe

PHAIDON · OXFORD

A QUARTO BOOK

Published by Phaidon Press Limited Summertown Pavilion Middle Way Oxford OX2 7LG

Reprinted 1991

First published 1988

Copyright © 1988 Quarto Publishing plc

British Library Cataloguing in Publication Data

Murphy, John
How to design trademarks and logos.
1. Trade marks. Design
I. Title
II. Rowe, Michael
602'.7

All rights reserved

No part of this publication may be reproduced, stored in a retrieval system, or transmitted in any form or by any means electronic, mechanical, photocopying, recording or otherwise, without the prior permission of the publisher.

ISBN 0-7148-2557-3

This book was designed and produced by Quarto Publishing plc The Old Brewery, 6 Blundell Street, London N7 9BH

Senior Editor Kate Kirby

Editors Lydia Darbyshire, Tish Seligman, Eleanor van Zandt

Designer Pete Laws

Picture Researcher Carina Dvorak

Art Director Moira Clinch Editorial Director Carolyn King

Typeset by Keyboard Graphics, London Manufactured in Hong Kong by Regent Publishing Services Ltd Printed by Leefung-Asco Printers Ltd, Hong Kong

Special thanks to Laura Beck, Janet Fogg of Markforce Associates, Mick Hill, Dr Jeremy Phillips of Trademark World.

CONTENTS

What are trademarks and logos?	6	
Types of trademarks and logos		16
Aesthetics		26
Developing the design brief		38
Developing the design concept		50
Case studies: hypothetical		62
The practicalities		82
Case studies: actual		96
Applying and maintaining the design		124
Developing new brand names		134
Legal aspects of trademarks and logos		138
Bibliography		141
Index		142
Acknowledgements		144

W hat are trademarks and logos?

ROLLS ROYCE

■ Above The Rolls Royce logo is a combination of the "word mark" Rolls Royce and the R.R. graphic device. Such composite marks can retain their coherence even when the name is changed. Right The logo is a clearly a rip-off of the Coca-Cola composite logo even though the name Coca-Cola does not appear.

EVERY SUCCESSFUL PRODUCT OR ORGANIZATION has its own "personality", and just as human personalities are complex so too are product and organizational personalities. The trademarks and logos of products and organizations are a means of condensing complex reality into a single simple statement, one that can be controlled, modified, developed and matured over time.

In fact, to talk about "trademarks and logos" as two separate things is somewhat misleading. Trademarks, the means by which merchants distinguish their products or services from those of others, fall into two main categories: *word marks* – for example the words Rolls Royce, Silver Shadow, Corniche, etc. – and *device marks* – the "Flying Lady" device used on Rolls Royce motor cars (properly known as the Spirit of Ecstasy), the Rolls Royce grill, etc.

Word marks are frequently referred to simply as "trademarks" and device marks, especially two-dimensional device marks, as "logos". In fact they are simply different types of trademark used by merchants to distinguish their products.

Further complications arise because many of the most famous trademarks in the world – Coca-Cola, Ford and Kellogg's, for example – are word marks shown in a distinctive graphic form. The composite mark is therefore both a word mark and a device mark. Coca-Cola would take grave exception to the pirating or unauthorized use of its name; it would also take grave exception to the pirating or unauthorized use of the distinctive Coca-Cola logo style with its red and white colouring and flowing script, even if the words Coca-Cola were replaced with other words.

Cartier

JOAILLIERS

■ Left Trademarks and logos form the most international language in the world. They cross boundaries readily and provide organizations with a ready means of delivering to consumers an unequivocal and uniform message.

NCR

British
TELECOM

Avis.

■ Above and right Logos are by no means the sole prerogative of commercial organizations. For example, the aims of the United Nations are clearly defined in their distinctive logo, right.

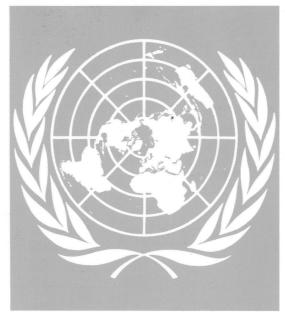

Also, even though the earliest trademarks, as their name implies, were used by traders and merchants, the use of distinguishing names and devices has been greatly extended, and nowadays hospitals, government bodies, private clubs and all kinds of organizations not involved in trading use trademarks of various kinds.

What has happened, of course, is that trademarks have become much more than mere distinguishing marks for products — they have become endorsements, indications of quality, value, reliability and origin. They have become a

■ Above A successful trademark and logo can develop into a valuable asset such as that created for Smirnoff yorka

form of shorthand that enables consumers to recognize products, services and organizations. A fragrance carrying the Chanel name and logo will be more highly valued than the one called Jenkins or Patel or Schwarz.

From the beginning of the 19th century the laws of France, the United States, Britain and other advanced countries started to recognize that trademarks were valuable pieces of property. It became possible to get official recognition of the ownership of a trademark or logo through registration and to sell or license the valuable rights built up in a particular trademark or logo. This has continued to the present, and "brands" are often sold for enormous sums. In 1987, for example, Grand Metropolitan of Britain bought the Heublein company from RJR Nabisco for well over \$1 billion. Most of the "value" in the transaction was undoubtedly attached to the Smirnoff trademark and logo -Smirnoff being one of Heublein's leading brands.

So trademarks and logos are more than just mere words or devices. They:

- *Identify* a product or service or organization.
- *Differentiate* it from others.
- Communicate information as to origin, value, quality.
- \blacksquare *Add value* at least in most cases.
- Represent potentially valuable assets.
- Serve as important *legal properties*.

A BRIEF HISTORY

Merchants have long used trademarks and visual devices to distinguish their products from those of others. A potter would identify his pots by putting his thumbprint into the wet clay on the bottom of the pot or by making his mark - a fish, a star or a cross, for example. We can safely assume that device marks, or logos, pre-dated word marks.

No doubt pride in manufacture played a part in this, but the good potter would also expect his customers to look out for his mark and buy his pots in preference to those of other potters. Of course, it suited the customer too. If you had bought pots that had served you well, you were more likely to buy others from the same potter than risk buying a product that might not be so good. Conversely, if one potter's product had proved unsatisfactory you would learn to look out for his mark and avoid it! Naturally, manufacturers of inferior quality pots quickly learned that one way of shifting merchandise, at least in the short term, was to put a mark on inferior pots to fool customers into thinking the pots were from a good, trusted potter.

Over the centuries trademarks and logos were used mainly on a local scale. The exceptions were the distinguishing marks used by kings, emperors and governments. The fleur-de-lis in France, the Hapsburg eagle in Austria-Hungary and the Imperial chrysanthemum in Japan indicated ownership or control. In a similar fashion the cockleshell, derived from the legend attached to the shrine of St James at Santiago de Compostella in northwest Spain, a favourite medieval centre of pilgrimage when the Holy Places of Palestine were closed to pilgrims by the Muslims, was widely used in pre-Renaissance Europe as a symbol of piety and faith.

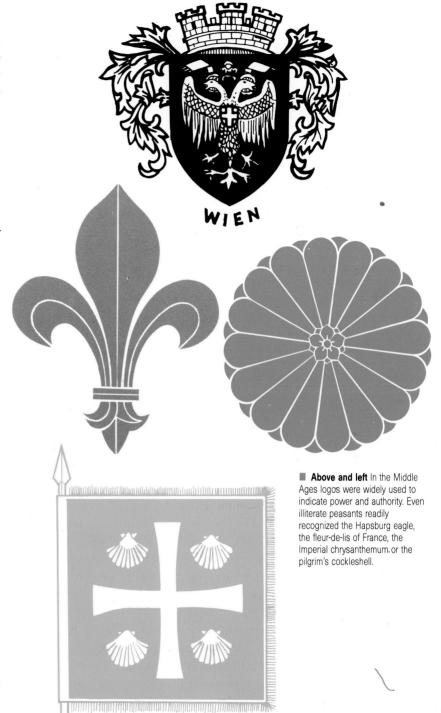

■ Trademarks and logos provided reassurance as to quality and origin. **Top and right** Markings on earthenware, fine bone china and porcelain are valuable to both the manufacturer and the purchaser. **Above** Hallmarks on gold and silver were developed to safeguard the consumer.

In the 17th and 18th centuries, when the volume manufacture of fine porcelain, furniture and tapestries began in France and Belgium, largely because of royal patronage, trademarks and logos were used by factories to indicate quality and origin. At the same time laws relating to the hallmarking of gold and silver objects were enforced more rigidly to give the purchaser confidence in the product.

However, the widescale use of trademarks and logos really dates only from a little over 100 years ago. In the latter half of the 19th century improvements in communications and manufacturing for the first time allowed the mass-marketing of consumer products, and many of today's best known consumer brands date from that period – Singer sewing-machines, Coca-Cola soft drinks, Bass Beer, Quaker oats, Cook's tours, Sunlight soap, Shredded Wheat breakfast cereal, Kodak film, American Express traveller's cheques, Heinz baked beans and Prudential insurance are just a few examples.

But it is the last 30 years that have seen the real explosion in the use of trademarks and logos. The birth of the television age has had a lot to do with this, as has the rapid growth of secondary and service industries. Shipyards, coal-mines and steel strip mills had little need for trademarks and logos, but snack food manufacturers, credit card companies, audio and hi-fi suppliers, computer companies and fast-food chains regard their trademarks and logos as being at the very heart of their businesses.

THE IMPORTANCE OF TRADEMARKS AND LOGOS

In developed economies consumers have an astonishing range of choice: there are, for example, dozens of different car manufacturers, hun-

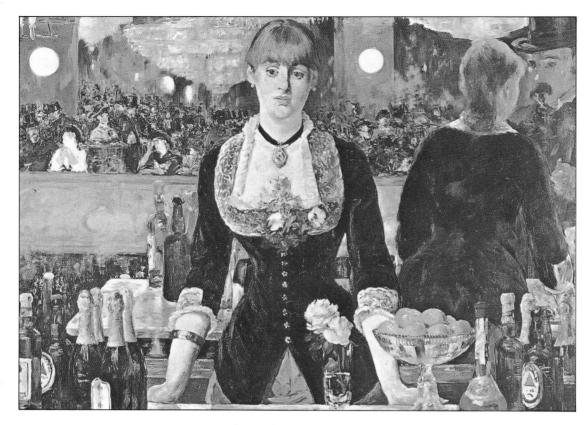

■ Some of the earliest registered trademarks are still in common use today. Below left The Bass red triangle was British trademark number 1 in 1876. Left Even in Manet's bar at the Folies Bergères of 1882, the Bass logo is clear. Below The Quaker man is well into his second century.

dreds of car models and thousands of different vehicle specifications to choose from. Gone are the days of "any colour you want so long as it's black". This diversity of choice puts great pressure on manufacturers to offer high quality, excellent value and wide availability. Therefore, even though a few products are manufactured to such high standards or offer such outstanding quality or value that competitors find it difficult to compete – Mars Bars and Kellogg's cornflakes, perhaps are examples – few products are shielded from direct competition by patent protection, proprietary know-how or a unique source of supply.

Much of the skill of marketing and branding is therefore concerned with building distinctive and

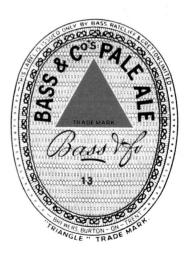

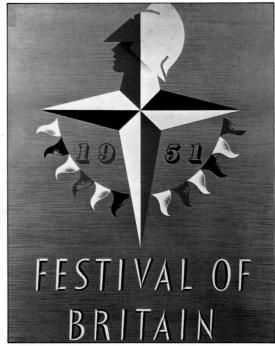

■ Left and below left Poster designs such as that for the 1951 Festival of Britain can afford to be voguish. After all, they are specifically intended for a single event.

differentiated brand personalities for products or services whose characteristics, pricing, distribution and availability are really quite close to each other. Take colas as an example. While there are undoubted differences between, for example, Coca-Cola and Pepsi-Cola and between these two products and the hundreds of other cola brands on the market, in practice the differences are subtle, perhaps even slight. Nevertheless these two brands are able to dominate the worldwide cola market. The power of their bottling and distribution arrangements no doubt plays a part in this, but the main factor is the strength and appeal of the two brands.

But just as brands are valuable assets and potent weapons for their owners, they are also valuable to the consumer. Brands allow the consumer to shop with confidence and they provide a route map through a bewildering variety of choice. If we wish to purchase petrol we know that the products of a Mobil station are reliable. We do not need to worry that they may be contaminated or overpriced – the Mobil name and logo provide us with an endorsement. It is the same with services; if we stay in a Hilton hotel we do not much have to concern ourselves about whether the restaurant is reliable or the sheets clean or whether it is possible to send a telex – the Hilton name is our guarantee of consistent, reliable facilities and of quality service. The trademark and logo allow us almost subconsciously to make a ready decision when faced with choices.

Trademarks and logos, the means by which organizations encapsulate and distinguish their products or services, therefore serve both their owners as well as the needs of consumers. It is clear too that they provide a potent incentive to their owners to maintain quality.

■ More robust logos adapt well to changing times. Far left The Camel logo has, for example, changed little though the positioning and appeal of the brand have evolved constantly. Left Even though the clothes have changed, the distinctive type for Moss Bros has been retained.

THE NEED FOR STABILITY

The following brands were all UK brand leaders in their categories in 1933:

HOVIS bread
STORK margarine
KELLOGG'S cornflakes
CADBURY'S chocolate
ROWNTREE pastilles
SCHWEPPES mixer drinks
BROOKE BOND tea
COLGATE toothpaste
JOHNSON'S floor polish
KODAK film
EVER READY batteries
GILLETTE razors
HOOVER vacuum cleaners

(Source: Saatchi & Saatchi)

All are still brand leaders today.

The following brands were all US brand leaders in their categories in 1933:

SWIFT PREMIUM bacon
EASTMAN KODAK cameras
DEL MONTE canned fruit
WRIGLEY chewing gum
NABISCO biscuits
EVER READY batteries
GOLD MEDAL flour
GILLETTE razors
COCA-COLA soft drink
CAMPBELL'S soup
IVORY soap
LIPTON tea
GOODYEAR tyres

(Source: Advertising Age, 19 September 1983, as quoted by Saatchi & Saatchi)

Again, all these brands are still brand leaders today.

It is apparent that brands have the potential for very long life, provided, of course, they are kept in good repair – i.e., guarded against lapses of quality, against counterfeiting, against product obsolescence and so on. While it may have been impossible to keep a brand of buggy whips contemporary and current through into the 20th century no matter how successful the brand was in the 19th, the best brands are potentially long-lived and robust.

The designer of trademarks and logos needs to keep this in mind. As we shall discuss later, it is often tempting to adopt a design style that looks terrific at the time but that can date very quickly. It is also tempting to change or tinker with logos after a few years – one year the trademark is in a box, the next in an oval, then it is green and later an attractive shade of gold.

Although there is no doubt that logo styles need up-dating from time to time – the pert symbolized typist of the 1960s with her piled-up hair and uplift bra can look very dated 20 years later – the designer should resist the urge to tinker unless it is really necessary. It is well recognized in advertising circles that consumers frequently start to notice a poster or a TV commercial only when the advertiser and the ad agency are heartily sick of the campaign. This is true of logos too.

Consumers are also very conservative. It takes a long while to develop the "visual meaning" and the association with a single product or company that you are seeking to establish, even using multi-million dollar promotional budgets. If you wish to modify or update this visual meaning you should do it gently and carefully – just as Mercedes, Shell, Coca-Cola, Westinghouse

■ Above Logos can date very quickly unless the designer is careful. The pert typist of the 1960s looks hopelessly out of date in an age of word processors.

Electric and other owners of leading trademarks and logos have done over the years.

THE NEED FOR DISTINCTIVENESS

One of the key functions of a trademark or logo is to *identify* a particular product, service or company. It follows therefore that the trademark or logo should be distinctive. Curiously, many designers, developers of new products and founders of new companies adopt trademarks and logo styles that are exactly like everyone else's. If all the existing powdered coffees on the market use gold packaging, gold labels and gold logo styles, so too will the new product.

Of course, the designer needs to be sensitive to cultural norms: a jazzy, electronic logo style would look out of place in a funeral parlour. Nonetheless, it is important to seek distinctiveness in trademarks and logos.

THE ROLE OF THE DESIGNER

The designer of trademarks and logos is not a mere draughtsman. In fact, he has to fulfil a number of different roles, especially those of:

- *Strategist* he has to work out a design strategy for his client.
- Researcher he has to explore and pull together a great deal of diverse information.
- *Creator* he has to use his creative skills and the data available to him to solve a design problem.

The process of designing a trademark or logo and the specific skills required are as follows:

The Process of Design	Skills Required
Developing a design brief	Conceptual
Gathering information about the client's requirements	Analytical
Developing design concepts or "models"	Modelling/creative
Presenting solutions and justifying them	Technical/interpersonal
	Technical/interperso

Technical

Implementing the

chosen solution

■ **Above** A designer needs to be aware of accepted styles. A flowing, convoluted graphic style is inappropriate for a construction equipment company; a more robust logo style is called for.

Types of trademarks and logos

dunhill

Above and below The most common type of logo is one consisting of the company's name in a distinctive graphic style without any accompanying symbol or device.

THE DESIGNER OF A NEW TRADEMARK OR LOGO has a wide variety of types of logo style from which to choose. These range from simple graphic representations of the name, possibly adapted from the signature of the founder of the company, to totally abstract symbols that can be used in conjunction with the corporate or product name or on their own. (The triangular device of the National Westminster Bank and the electric flash in a circle of Opel are examples.)

Not all these logo styles work equally well in all situations, however, and an understanding of the various types of logos available and of their applications can be of value to the designer in narrowing down his options.

NAME-ONLY LOGOS

In the early days of branded products it was common for the owner of a business to put his signature on his products – he literally applied his mark or brand to his goods. As the business

grew, an actual signature was inevitably superseded by a printed signature, and it became common for manufacturers to place advertisements stating "none genuine without this signature" or "beware imitations – look for the signature". The signature was an indication of quality, value and origin, and unscrupulous traders would seek to copy it.

Over the years the original signature was frequently developed into a distinctive logo style – as for instance with Harrods, Kellogg's and Boots – or it became an integral part of a product label – as for instance with a number of Scotch whisky and other liquor brands.

In other instances, even if an actual signature was the basis of an early logo style, it has long been discarded. Examples of "contrived" name-only logos include Pirelli and Dunhill.

Name-only logo styles – logo styles that derive their uniqueness exclusively from a name used in a particular graphic style – give an un-

Kelloggis AVON

XEROX Harrods

equivocal and direct message to the consumer. In an age when the cost of media and of reaching the consumer is becoming ever greater and when the plethora of messages competing for the consumer's attention is growing steadily, a simple, direct message has a lot to commend it.

Name-only logos are, however, normally appropriate only when the name is relatively short and easy to use and when it is adaptable and relatively abstract.

Merrill Lynch, Pierce, Fenner and Smith or National Westminster Bank, for example, would have difficulty using a name-only logo – the names are quite long and, in a sense, unwieldy, and they would, therefore, be difficult to use in many situations. Such names demand either a contracted form or a simple graphic device for situations in which the use of the full name would be inappropriate.

Leica

Many corporate names are the surname of the company's founder and the resultant logo style is often based on his or her distinctive signature. In other instances a contrived name will be given a unique graphic representation.

Wilson®

TIFFANY&CO. BRHUN Scripto

NAME/SYMBOL LOGOS

■ Above A logo style based upon the signature of the founder is given extra distinctiveness by the use of a simple graphic device – an oval. Below More elaborate logo styles can be evolved by presenting the name in a distinctive visual symbol. The Levi logo, for example, echoes the patch pocket on a pair of jeans. In the Nike logo, the curve adds dynamism and energy.

These logos comprise of the name in a characteristic type style but contained within a simple visual symbol – a circle, an oval or a box. Ford, Texaco, Du Pont and Fiat all adopt such an approach. As with name-only logos, the name must be relatively short and adaptable because the abstract symbol will not have sufficient distinctiveness to stand on its own. Whenever the logo is used, the corporate name necessarily plays a key role in the communication. Whether the logo is used on a truck or an annual report, a sack of coffee or an oil filter, the name must be at home there because it constitutes an integral part of the logo.

INITIAL LETTER LOGOS

"What's good enough for GM and IBM is good enough for me!" Well, maybe. It is tempting for companies or partnerships to adopt a fairly cumbersome multi-word name. Such names may perhaps be based on a description of what they do (Universal Winding Corporation, for example) or they may be a joining together of the names of two partners in a merger (Cadbury-Schweppes, for instance) or they may even be based on the surnames of the founders of the business (as in Wight Collins Rutherford Scott). The organization frequently finds that the new name is unwieldly and settles for using the initials on their own. It then tries to invest a set of

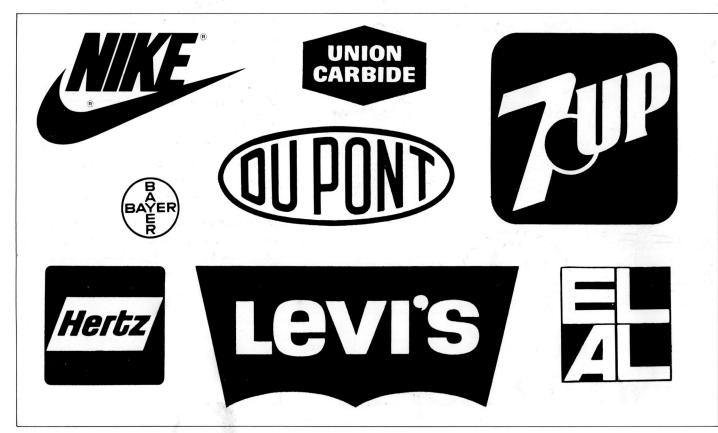

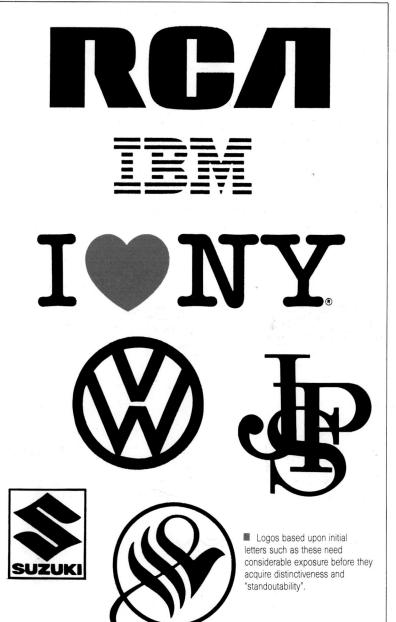

WESTIN HOTELS

initials with character and distinctiveness, partly through the adoption of an attractive logo style.

In practice designers often find that the development of logo styles based only on initial letters is a fairly straightforward task. It is a relatively "pure" design job, and the designer can often take particular pleasure from the exercise of his skills. However, even though initial letter logos can be interesting for the designer, they can have serious pitfalls for the client:

- It can be difficult and expensive, perhaps even impossible, to invest initials with real personality and distinctiveness. In certain sectors for example trade unions and other non-profit making organizations a sort of alphabet soup can develop, which insiders know and understand but which is totally impenetrable to everyone else.
- It is always difficult (and in most cases impossible) to gain exclusive legal rights to a set of initials.
- Initials can be frustrating to the consumer. It is difficult to look up an organization by its initials in a telephone directory, especially if you do not know what they stand for.
- It is possible that the initials may have to vary from one country to another NATO, the North Atlantic Treaty Organization, is known as OTAN, Organizacion Tratado Atlantico Norte, in Spain.

So, if your client has not yet chosen a name, ask him to consider carefully whether a name that will inevitably rely for communication on its initials is really appropriate.

■ Left and right A distinctive visual symbol can, when linked with a name, lead to an outstandingly strong logo.

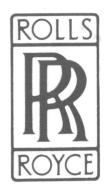

PICTORIAL NAME LOGOS

These are logos in which the name of the product or organization is a prominent and important component of the logo style but in which the overall logo style is very distinctive. Even if you presented the logo substituting a different name it would still clearly be the logo of its owner.

Examples include the distinctive logos of Coca-Cola and Rolls-Royce. If these two corporate names were transposed, the distinctiveness and integrity of the logos would remain and the transposition would be obvious. Indeed, both of these logos have become so invested over the years with visual meaning and association that to transpose them in this way would be jarring and slightly shocking. The composite name/design combination forms such a distinctive logo style that it defies tampering of this sort.

ASSOCIATIVE LOGOS

Associative logos are free-standing logos – they do not usually contain the product or company name, but they do have a direct association with the name, the product or the area of activity. Examples include the distinctive shell device of Shell Oil, the racing greyhound of Greyhound Corporation, Monsieur Bibendum of Michelin (a character built up from pneumatic tyres) and the "British-style" coat of arms in the logo of British Airways.

Associative logos are therefore simple and direct visual puns. They have the advantage that they are easy to understand, and they provide their owners with considerable flexibility – the graphic device instantly represents the product or company in a simple and direct way. An outline shell logo on a can of oil or on a piece of literature says "Shell Oil" just as powerfully as does the name.

Of course, not all corporate and product names lend themselves to simple associative logos of this type or the obvious logo might be inappropriate. Also, a pun in one language might have no meaning whatsoever in other languages and could be viewed in many markets as a purely abstract graphic device.

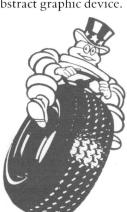

■ Left and right Logos which encapsulate the essence of the company's name or products or philosophy are particularly interesting. What could say more about motherhood, for example, than the Mother and Child logo? The logo of Cubic Metre, an office design consultancy, carries a message of "ordered space".

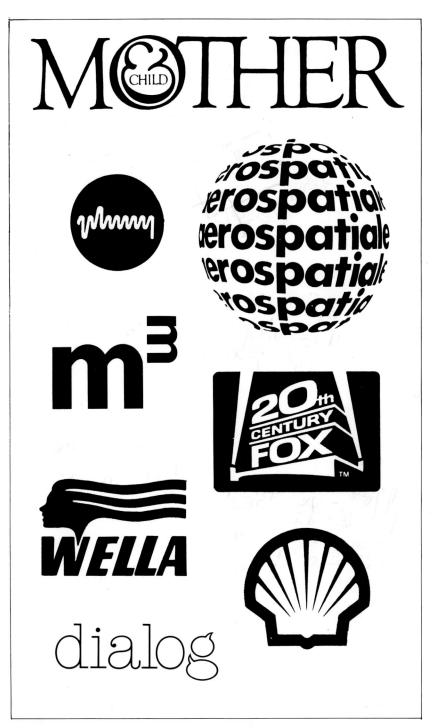

ALLUSIVE LOGOS

The Mercedes "star" has been said to allude to the spokes of a steering wheel, although the relationship may be purely coincidental. But the distinctive "A" logo of Alitalia, the state airline of Italy, is surely designed to bring to mind the tailplane of a jet airliner. Similarly, the Indian arrowhead used by Anaconda Industries is an allusion to early Indian copper-mining and the waves within the Philips shield to sine, or radio, waves.

The connection in these examples between the name and the logo is by no means as direct as with associative logos, and indeed the allusion may be lost on the majority of the audience.

Nonetheless, the allusion provides a focus of interest that can be useful in public relations terms, especially when a new logo is being launched. Also, employees, customers, investors and other interested parties often seem happier with a logo that has some core of meaning than with a purely abstract logo. In a sense, the allusion contained in the logo becomes a form of secret, shared by those "in the know" but often lost on outsiders.

■ Left and right In some logos the original concept behind the design is obscure to all but the initiated. The Mercedes logo is said to allude to the spokes of a steering wheel, the Philips logo to radio waves and the Wool symbol to a skein of wool. But in all these examples, the allusion is subtle and is probably lost on most people – the logos will be viewed as essentially abstract.

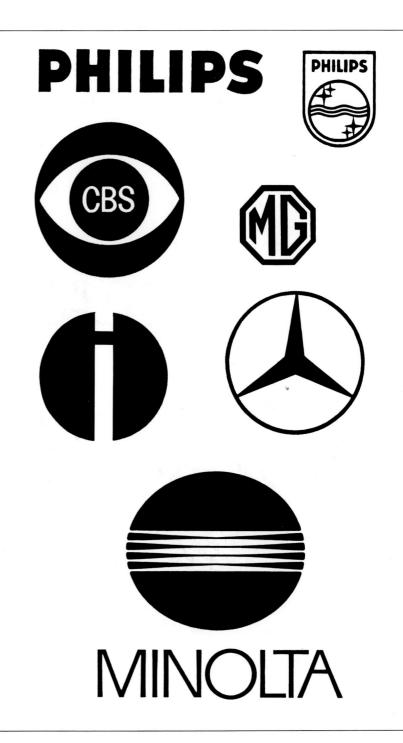

Dictaphone

ANACONDA Industries

ABSTRACT LOGOS

Many of the logos in use today are purely abstract or, at least, any allusion or meaning is so remote that they are purely abstract for all practical purposes. The National Westminster Bank triangular logo device, the Chrysler logo device and the devices of Rockwell, Kenwood, Mont Blanc and scores of others fall into this category.

With abstract logos the designer is given a blank sheet. He can design "a structural shape which creates a varying optical illusion" (as Robert Miles of Runyan & Associates, Los Angeles, described the new logo they designed for City Investing). Alternatively, a designer can use the logo "to convey the industrial strength of products and feeling of movement associated with their function" (as William Cagney of RVI Corporation described the logo he designed for USEMCO Inc, a manufacturer of water and

sewage lift-stations marketed to municipalities).

Abstract logos seem to be particularly favoured in the United States, where their execution has reached a level of considerable refinement. The reason for their popularity stems partly from the diversified nature of many of the large US corporations. Such corporations do not want a logo that, in either origin or product terms, favours or is particularized to one part or division of the corporation over another. The obvious answer to such a requirement is an abstract symbol. This movement has been reinforced by the success of Japanese business in the West, because the apparently abstract corporate logos of Japanese companies have worked well in the marketplace. (In fact, in a Japanese context many of the logos are not abstract at all, but their subtleties are not recognized outside the home market.) Thus the use of abstract logos by suc-

Above and right You will see that these logos are almost entirely abstract, though in some instances the abstract symbol is used in close association with the company name.

cessful, dynamic enterprises has led to their becoming very fashionable. Abstract logos are now often viewed as representing the quintessence of contemporary trademark and logo design.

The problem of such free-standing, abstract logos is the very fact that they have no real core of meaning. A big rugged company making heavy metal castings may of course somehow "demand" a big rugged logo; a speciality, high-quality textile producer may well somehow demand a logo that is intricate and that "echoes" the intricate joining together of threads to form a fabric. Apart from these fairly subtle associations, however, abstract logos are, in effect, meaningless and need to be invested with significance. This process of investing an abstract logo with meaning can be costly. This might not greatly concern a major TV station, a bank or an

industrial conglomerate, but it can be a problem for a smaller company seeking to get attention in a crowded marketplace.

The problem is further compounded by the fact that so many abstract logos, seem to be similar to each other. In the search for simple, uncluttered logos, a "soup" of relatively undifferentiated logos has emerged. The logos are skilfully executed and aesthetically satisfying, but they often tend to look much the same. As the function of a logo is to identify and differentiate the organization, product or service, this is obviously unsatisfactory, particularly for the newcomer into the market.

Abstract logos need therefore to be handled with care. Coming up with a design solution that does the job and is appealing but that is differentiated from others is difficult and requires effort and skill.

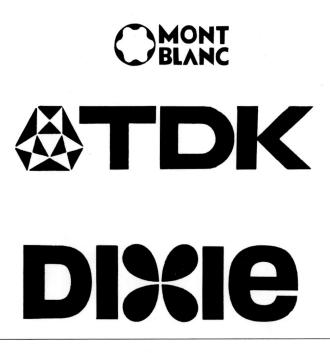

A esthetics

Any item of design, be it a jet aircraft or a piece of abstract art, combines both practical and aesthetic elements. Of course, in an aircraft the practical elements are of overwhelming importance and the aesthetic considerations are secondary - the major requirements is a plane with good performance, fuel economy, carrying capacity, operational qualities and so forth. If, in addition, it looks terrific, this is a real and valuable bonus. In a piece of abstract art the practical performance aspects are of relatively little importance as the object is not expected to "work" in any practical sense; nevertheless, in recent years museums and owners of modern art have come to realize that even art should meet certain minimum "performance" standards, as many modern paintings and sculptures are already falling apart because the artists used inappropriate methods or materials. The artists of previous generations, it seems, combined the practical and aesthetic aspects more skilfully than do our contemporaries.

Trademarks and logos, as pieces of design, fall perhaps midway between jet aircraft and modern art – they have a real job of work to do and they must be "constructed" to be fit for their purpose, but they also involve powerful elements of taste.

It is perhaps understandable that modern artists should overlook the practical aspects of their art and focus largely on the aesthetic, but it is more curious when designers of trademarks and logos do the same thing. After all, a trade-

and definition of the part of

mark or logo is, in large part, a business tool. Nonetheless, many designers of trademarks and logos like to construe what they do as a purely abstract or cerebral creative process: they sit down with a blank pad and a felt tip pen, and the perfect design somehow flows out of the end of their pen and on to the page.

Of course a skilled designer is in fact working to practical rules based upon training, experience, investigation and intuition. He is following a logical and practical process but choosing to portray the process as being one solely of creation unfettered by non-aesthetic considerations. Much of this book is, therefore, concerned with exploring those practical, sensible "rules" that should be followed by the designer of trademarks and logos and that all skilled designers follow, although perhaps unconsciously.

But what of the aesthetic component of trademarks and logos? Can the aesthetic elements of logos be explained and understood?

The successful designer of trademarks and logos needs to have basic intellectual and draughtsmanship skills in addition to a sensitivity to the aesthetic elements of design. But this, of course, is a common requirement – a person who is tone deaf could never for example function well as a musician. Given, however, the basic endowment of skills and attributes, aesthetic skills can be acquired by a designer.

STRAIGHT LINES

A straight line is a straight line is a straight line. Well, perhaps. Leaving aside for the moment questions of colour, consider the (more or less) straight lines shown here. The first is fine and

delicate, and, if used extensively in a logo, it would tend to create a delicate filigree effect. The second, a strong, bold line is confident and controlled. The third, almost straight line is informal and somewhat relaxed.

Let us use these lines on an established logo, in this case the Transax international cheque guarantee service. Transax enables a retailer to accept a cheque from a customer above the normal limits guaranteed by a bank provided that

TRANSAX

TRANSAX

TRANSAX

the cheque has been cleared by Transax. Transax guarantees payment of the check and, in return, receives a small fee on each transaction. Many customers find the idea that their "credit worthiness" is to be investigated by a third party before their cheque is accepted a little unnerving; retailers on the other hand want reassurance that Transax is reliable and will stand behind its guarantee. The logo has, therefore, to help in two important respects; it has to reassure retailers and, at the same time, be approachable and not intimidating to consumers.

Using fine, delicate lines is somehow unsatisfactory, both aesthetically and practically. The lines make the logo a little weak, and the name somehow floats in space. It is less reassuring than it should be to retailers, but it is still not approachable or friendly to consumers.

The use of the stronger lines in the second logo is an improvement, but the overall effect is somehow too rigid and controlled.

■ Above By varying the nature of the straight lines in this Transax logo, the whole tone of the design can be changed. 1 The logo treatment is weak. 2 The thick lines make it too rigid and heavy. 3 The more informal hand-drawn lines here are strong yet relaxed - the effect preferred.

Overleaf The five typefaces illustrated are, from left to right: 1 Franklin Gothic Condensed; 2 Garamond Light Italic; 3 Avant Garde; 4 Lubalin Graph Bold; 5 Balmoral. Underscoring will effect the impact and as shown overleaf one style can be more suitable for one typestyle than another.

Fine underscore This rule is as clearly comfortable under 3 and 5 as it is uncomfortable under 1 and 4.	DESIGN	<u>DESIGN</u>
■ Double fine rule The double rule helps with 1 and 4 but seems to work against 2 and 3.	DESIGN	<u>DESIGN</u>
■ Thick'n'thin rule This looks good under 2 but has no particular affinity for the others.	DESIGN	<u>DESIGN</u>
■ 4 point rule This is possible for 1 and 4 but it is getting too heavy for 3 and 5.	DESIGN	<u>DESIGN</u>
■ 12 point rule For stark impact this works under 1 and 4 again but it overpowers the rest.	DESIGN	DESIGN
■ Brushstroke None of the typestyles shown here is informal enough to be really successful with this idea.	DESIGN	DESIGN

DESIGN	DESIGN	<u>Design</u>
DESIGN	DESIGN	<u>Design</u>
<u>DESIGN</u>	DESIGN	<u>Design</u>
DESIGN	DESIGN	<u>Design</u>
DESIGN	DESIGN	Design
DESIGN	DESIGN	Design

The impact of a logo can be varied or modified by careful selection of the detailed features surrounding it. **Above** A square corner on a box may be plain but some logos call for such treatment.

By rounding the corner on a box the effect becomes rather more informal and less engineered.

Knocking off the corner restores the formality but adds interest.

An inverted curve is gentle with an old-fashioned feel to it.

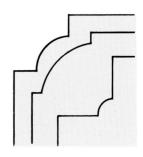

An elaborate scalloped corner can be elegant, even somewhat baroque.

Perfume

PERFUME

■ Top The copperplate typestyle coupled with an intricate border produces a logo style that would be ideal for a coffee shop in old Vienna or, perhaps, an expensive

parfumier. **Above** The more modern typestyle is younger and fresher and the border bolder and less fussy. The effect is altogether more youthful.

The third logo better meets the dual objectives. The informality of the hand drawn lines helps to relax the logo, which would be significant to consumers, yet it is still a strong, reassuring logo from the retailer's point of view. This logo is also more aesthetically pleasing; it is less contrived than the others and more the product of thinking, breathing human beings.

So, even a straight line can have both aesthetic and practical qualities.

CORNERS AND CURVES

Similar considerations apply to other elements of design. There are few straight lines and corners in nature. If you use perfect corners in a trademark or logo design you are making a statement about the product, service or company represented by that logo – a perfect corner implies precision and structure; a rounded corner is more relaxed.

If Messrs Andersson manufacture highprecision parts for power stations the simple logo shown below might suit them well, but, if Messrs Andersson are food retailers, they should consider the second option. After all, we are all sufficiently concerned about "healthy eating" not to wish to purchase food from retailers who present a technical, "factory-made" image.

BALANCE

With experience designers acquire a delicacy of touch, an ability with the elements of design and a sense of proportion and balance. Good artists use precisely the same skills when composing a picture; their pictures are balanced and cohesive, the eye is led naturally around the picture in a controlled fashion, and the overall effect of the picture is pleasing: the action is not confined to one area of the picture but is arranged in a balanced, controlled way.

The same considerations apply to trademarks and logos. Consider the Coca-Cola logo. It is, apparently, a relaxed, free-flowing logo, yet it is carefully crafted to preserve balance and integrity. Note, for example that, the two capital Cs are quite different from each other; the second C is altogether more elaborate and has been used to harmonize and balance the overall effect.

SHAPES AND SOLIDS

In 1987 Britain's Imperial Chemical Industries, most commonly known as ICI, spent many mil-

■ Right above When Messrs
Andersson were precision
machinists they used this logo
style. Right below When they sold
up and became food retailers a
less "engineered" image was
required. But do the rounded
corners do enough?

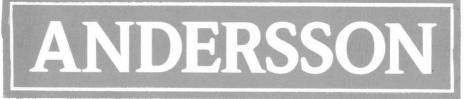

ANDERSSON

lions of pounds on overhauling its logo and presenting it to the world. ICI has a reputation for being a hard-headed, practical company; it is not known for spending its money without purpose. What makes the new logo sufficiently better than the old to justify such an elaborate and expensive programme?

No doubt the company, in making the change, had a number of different objectives, not all of which directly concern the designer. It could be (although we do not think this is the case) that the chairman loathed the old logo or even that the company was simply seeking a "hook" for an image-building programme. More practically, the company had become concerned that the old logo with its serifs and wavy lines, was a little too fussy and old fashioned. The company also felt that the logo was somehow too insubstantial and effete for one of the world's major speciality chemical companies.

The solution ICI adopted, in addition to generally tidying up the typeface and the wavy lines (believed originally to represent, for some reason, the sea) was to reverse out the logo and show it in solid form. Considerable consumer research into the new logo was carried out, and a solid logo was widely considered to be more substantial and powerful than the previous logo.

When the revised logo was unveiled in late 1987, many designers said that they could have

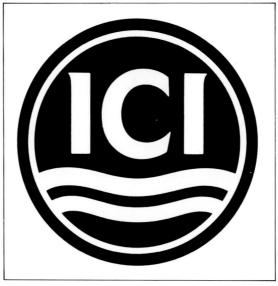

told the company that a solid logo was better than the old logo and that they could have saved the company a lot of time and money. Both consumers (for practical reasons) and designers (for more aesthetic reasons) agree that a solid logo is more appropriate to a powerful, international company.

FASHION

Of course, when ICI's earlier logo was adopted some quarter of a century before, an "open" style was preferred. So what has changed?

We all know that what is fashionable at one time can appear hopelessly dated only a few years later – consider how the fashions of 10 or 15 years ago look to us now (in a later chapter we discuss the need to keep logos up-to-date and contemporary and the need from time to time to review logos and up-date them, although usually in quite subtle ways). But "quality" work is somehow more timeless and robust than poorer work. We all know that the major paintings of the Renaissance are quite different from those

■ Above The old ICI symbol was used for over 20 years but research showed it was becoming dated and a little tired. Left The new ICI symbol has been reversed out, the typeface has been tidied up and the wavy lines have become less so. But the visual meaning and equity in the logo has been preserved in full. Above left Companies like ICI and Coca-Cola invest heavily in their corporate identity and are careful not to throw this investment away when up-dating their logos.

The tonal qualities and messages inherent in a simple square can vary widely. The finely ruled square above is light and unobtrusive. It gives the eye a visual reference and prevents material from floating in space.

The double ruled square is more contrived – the statement is firmer but pretending to be coy.

With this thicker ruled box, the effect is stronger, even funereal – it does not aim to let anything out.

The thick'n'thin ruled box is firm and controlling but the two rules take away the funereal effect.

A solid black square commands attention. A reversed out logo on a black background needs careful checking as it can play tricks with the eyes.

This heavy black border is simple and easy to reproduce but it is boring and non-distinctive.

A square with a shadow requires more elaboration to become a logo – it somehow does not have sufficient substance.

This hollowed out cube is better, but it looks uncannily like many other logos.

A pyramid viewed from above may be too delicate for the required applications.

The same applies to this clever spiral effect, but again it is probably too intricate for practical application.

These three examples show how the treatment of the square can be used to compliment the effect of the logo. **Left**This logo for a publishing house would be

overpowered by the solid black border (right). **Centre** Quintess Antiques Ltd needs the extra border line. **Right** This gas company logo has an efficient

contemporary book which would be lost in a finer border.

■ Above A colour wheel is, in effect, the colour spectrum made into a circle. Hue is simply the position of the colour on the wheel – green, yellow or red, for example. Tone describes its lightness and darkness; intensity its power or impact. When placed next to each other some colours tend to conflict, others cancel each other out and some modify each other to produce an additional colour.

■ Right Georgia Deaver's letterhead bears witness to her skills as a calligrapher and hand letterer. The colour gradations suggest the colours in fine marbled papers. Inset Thumb Design uses strong splashes of colour to pick out key items on its letterhead.

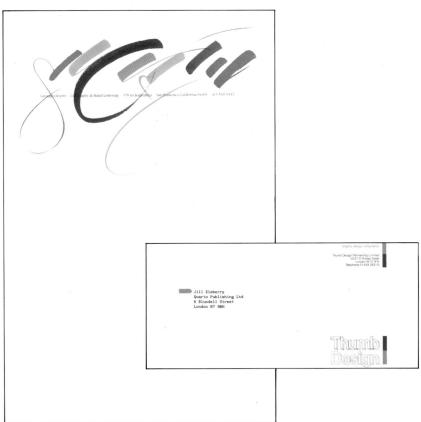

The four basic printing process colours: cyan, yellow, magenta and black.

Subtle graduation takes you from blue through to green.

These shades tone well and suggest warm earth qualities.

produced by contemporary artists and that they are, in one sense anyway, hopelessly dated and old-fashioned. They are, however, massively appreciated and regarded as being among the greatest artistic masterpieces in the world.

So, even though fashions may change and certain styles or colours or treatments may be considered for a time more fashionable or desirable than others, the basic aesthetic qualities of a trademark or logo will remain and will continue to be appreciated. Also, logos that are balanced, cohesive and well crafted are remarkably robust: they can be up-dated, modified, reversed out or otherwise changed without their integrity being destroyed.

COLOUR

The choice of colours also demonstrates the need to balance fashion against more enduring aesthetic values.

A firm of management consultants, McKenna & Co, wishes to appear serious and professional but not stuffy. Using burgundy or dark blue in the logo achieves this; the logos are attractive and satisfying yet are neither flippant nor pompous. Pink, however, is somehow unsatisfactory. Although it may be today's colour and be seen everywhere, it is somehow not suitable for a firm of management consultants. It is neither aesthetically satisfying nor appropriate.

SOMEEXAMPLES

An ear of wheat is a simple graphic device, yet, by varying the thickness of straight lines, using curves, reversing out, introducing different "frames" and using different colours, this simple device can be portrayed in many ways. The "emotional impact" of the device can be greatly varied and the "message" contained in the device

McKenna & Company MANAGEMENT CONSULTANTS

McKenna & Company
MANAGEMENT CONSULTANTS

McKenna & Company

■ Above McKenna and Co is a serious firm of international management consultants but it is not stuffy. Burgundy or dark blue is attractive and appropriate but shocking pink does not fit the bill at all.

■ Right A simple ear of wheat can be portrayed in scores of ways yet still remain unequivocally an ear of wheat. It can be drawn sketchily, loosely, even in a sloppy fashion, or in a very precise, controlled way.

can be modified to suit one use or another. Thus an angular, mechanistic rendering is striking and a little shocking

Of the wheat ear logos illustrated, most represent competent, balanced designs that are all, more or less, aesthetically satisfying, but they vary from each other mainly in that each is more suitable to one application or use than another. A couple of the designs however are not even worthy. The wheat ear in a triangle, for example, is aesthetically unbalanced and inappropriate. There is no "fit", and the effect is unsatisfactory.

Aesthetics, therefore, play an important role in the design of trademarks and logos. Aesthetics are not about taste, about whether a logo is shocking or otherwise or about fashion. Aesthetics are about sureness of touch, balance and the harmonization of the different elements that go to make up a design.

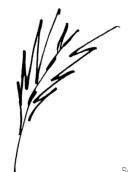

First, a quick, loose rough sketch to see what that produces. A dramatic shape, but too vague.

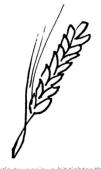

So let's try again, a bit tighter this time, using a reference (far left). This is more detailed and distinctive but not very exciting.

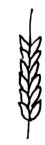

Let's try abstracting the idea a little by tidying it up and straightening the stalk. It's a bit thin and spindly...

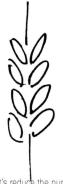

...so let's reduce the number of grains and open up the design. Still not distinctive enough...

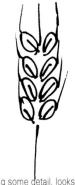

...adding some detail, looks more interesting but now it's too cluttered.

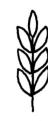

Let's remove most of the detail and make the design more formal. The image is lost – it could be any plant or tree. The number of grains are about right but...

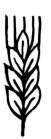

...the image definitely needs detail to give it some identity although the whiskers, being the most distinctive characteristic, will probably be enough.

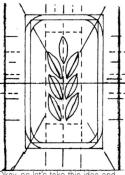

Okay, so let's take this idea and draw it up more carefully, placing it within a rectangle with rounded corners, which sympathize with the roundness of the grains, to hold it together.

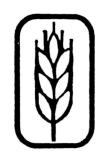

So, the initial sketch leads to this image which is well worth developing (see opposite page).

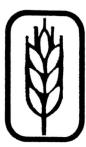

The stylized ear of wheat is comfortable within this shape but the whiskers need to be longer...

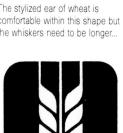

...and put the image back into a rectangle but keep it negative. This is good but the space either side of the wheat ear makes the whole thing uncomfortably vertical.

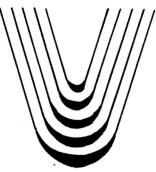

Although you may have arrived at what may well be the right solution for the job, never give up the possibility of further exploration. The examples above

...so let's make them longer but within a different shape. This doesn't work at all - the triangle is unsympathetically sharp.

Let's turn the rectangle into a diamond to make it less vertical. Nearly there but still too sharp and the space either side still interferes too much with the image, so...

and right show just how far you can go with either a highly stylized or very free image and still retain an identifiable and meaningful solution. In different

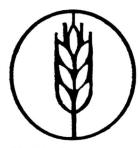

The circle reflects the roundness of the grains but there is too much "air" on either side. One way to reduce the space is to make the image less linear by making it negative...

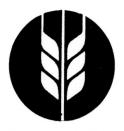

...it's back to a circle. This is it! The space around the ear of wheat achieves exactly the right balance all around it and the symbol is immediately identifiable as what it sets out to be while being uncluttered and aesthetically pleasing.

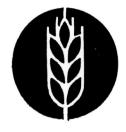

...but doing this highlights the uneven line around the grains. So let's simplify the grains further...

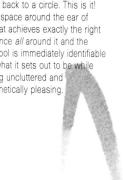

D eveloping the design brief

Designers sometimes like to suggest that there are no rules in design and that the process they follow in arriving at a design solution is unfettered by convention, rules or even fashion. While it is true that some of the most brilliant designs – like the most brilliant art, architecture, or the most brilliant inventions or pieces of music – bend the rules or fly in the face of established fashion, in practice the brilliant designer applies the rules in a fresh or a creative way but does not tear up the rulebook altogether.

Take the example of motor cars. The first transverse-engine front-wheel drive motor cars were extremely novel. They allowed their designers to develop compact, manoeuvrable, low-cost vehicles with startling levels of road-holding, economy and interior space. But they still had four wheels, albeit rather smaller than hitherto, they still had seats, a steering wheel, front and rear lights and so on. Fresh, novel and creative designs for motor cars were produced, but they obeyed a general set of rules.

Right A Leonardo da Vinci drawing which foresaw the invention of the helicopter. Both this and the jet engine diagram (above) – shown with inventor Sir Frank Whittle – were brilliantly original designs which applied basic laws in a fresh and novel fashion.

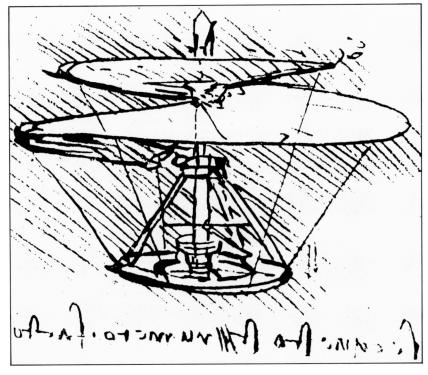

■ Right You should attempt to achieve originality in the logos you design; you will not achieve this if you base your ideas on such overworked concepts as capital letters and the globe.

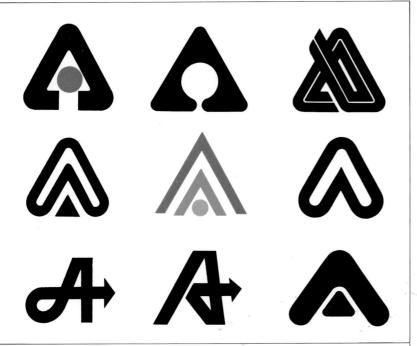

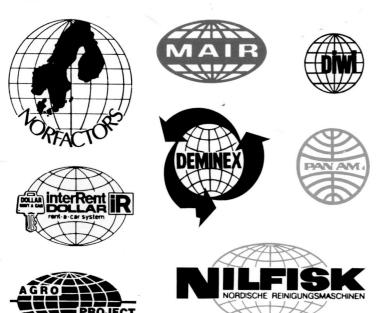

Similar rules apply to the designers of trademarks and logos. These rules flow from budgetary considerations, from the nature of the product, company or service and from the timescale over which the design is to be used. The result is that designers tackling similar problems often come up with relatively similar solutions: formal typestyles for doctors and health centres; angular, high-tech solutions for computer software companies; dramatic colours and logo styles for designer clothes stores.

But many apparently similar design solutions are dictated more by fashion and lack of imagination that by external rules. Much design is imitative, even banal. It is often easier for a designer to knock together a hybrid approximation of the logo style of his clients' main competitors than to come up with something original.

The dilemma of the designer therefore is to achieve a fresh and interesting design solution within broad constraints and rules.

GATHERING INFORMATION

The logo or trademark normally has to do two main jobs:

- *Distinguish* the company, product or service.
- *Differentiate* the company, product or service from similar ones and all in an appropriate, attractive and legally protectable way.

The first task of the designer is to find out as much as he reasonably can about the product or company, about market conditions, pricing, the competitive situation, the "positioning" or market stance of the company or product, the scope of international use, if any, the duration of use, advertising plans, plans for range extension, likely licensing plans and so on.

The logical starting point for this information is your client. Start your data-gathering by sitting down with your client and crossquestioning him or her about these matters. Your client will generally have been immersed in the project and will have a good idea of what he wants, even if he has not formulated a tight design specification. In a sense it is your job to help your client crystallize a design solution. You are a specialist consultant whose job is to interact with your client to solve a complex business problem. You are not an intelligent drawingmachine that your client has rented for a period and then puts back in a box. Some of the information gathered in a face-to-face discussion with your client will profoundly influence the design solution you propose to him.

BUDGETARY CONSTRAINTS

Your client is a housing trust, part of a charitable group specializing in helping the homeless. The trust is run by a few full-time staff, who are paid only modest salaries, and a small army of unpaid, part-time helpers. Although the assets controlled by the trust are substantial, attitudes within the trust are extremely frugal. For a client of this sort it would obviously be inadvisable to suggest a design solution that is costly to implement and maintain. Even if your initial design proposal

were accepted, the design would quickly become corrupted as members of the trust sought to introduce economies.

PRODUCT CONSTRAINTS

A logo or trademark should be sensitive to the nature of the product. The logo design of a sleeping tablet, even a powerful, prescription-only drug, could be colourful, light, even carefree, but to use such an approach on a drug for the treatment of cancer patients may be both insensitive and inappropriate.

PRICING CONSTRAINTS

You have to develop a logo for a new fragrance that retails at £200 an ounce. It is obvious that the logo should be stylish and sophisticated. Certainly a commonplace or unsophisticated design would be out of the question.

COMPETITIVE CONSTRAINTS

The existence of strong, entrenched competition can provide you with a clear set of established design attributes that need to be followed for the new trademark or logo. On the other hand, it could lead you in a completely new direction.

Suppose you are developing a trademark or logo style for a range of own-label foods for a major supermarket chain. You may wish to

■ Above and below The logos of expensive, sophisticated products should themselves be stylish and sophisticated.

GIVENCHY

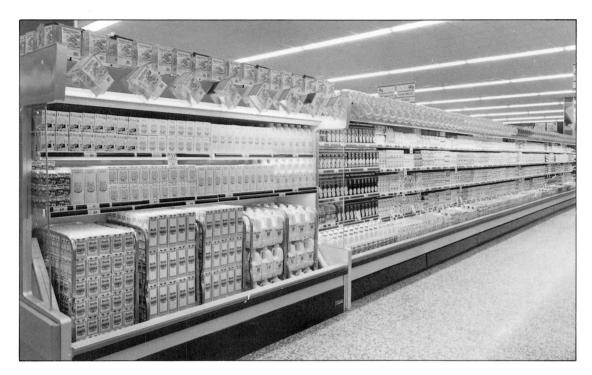

■ Left and below The consumer today is confronted with an astonishing range of choice. Your logo design should help the product command attention and make it stand out from the crowd. In a modern supermarket the product must work hard to get noticed.

develop a very conventional design route that clearly positions the new products as a mainstream range within the existing food culture. The design approach would, in this instance, be entirely conventional.

On the other hand, if your client is the 23rd or 66th entrant into an established market, if his product is broadly similar to those already available (as is normally the case) and if he has no "tied" outlets (as is also normally the case), it may well be ridiculous to adopt a logo style that is similar to the 22 or 65 existing products already on the market. After all, if the logo style and other attributes of the new product are broadly similar to the many existing products on the market, why should the consumer give the new product a second glance? In such a case the most sensible design approach may well be one that is innovative and different, that steps outside

■ Right In less than 10 years the popular Cariba brand of soft drink has had three quite separate pack designs but the UK consumer still recognizes it – brands can be robust assets even when they are tinkered with.

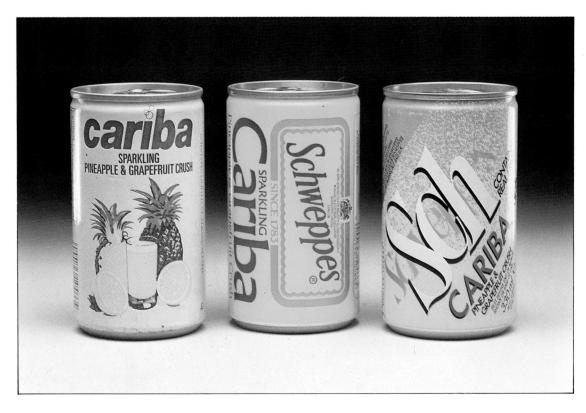

the apparently prescribed norms dictated by the competition and that catches the attention of consumers.

Innovative branding approaches of this type can create interest and differentiation and they can also help to show up the existing products as being staid and old-fashioned. But clients, who are frequently more attracted by conventional solutions than are consumers and who frequently prefer a likely 1 per cent market share to a possible 20 per cent, can be very difficult to persuade!

POSITIONING CONSTRAINTS

Today's markets are very crowded and very competitive. Few products or companies are differentiated from others in a profound way. Much of modern branding is about taking relatively undifferentiated products, companies or services and accentuating the differences between them, albeit differences that initially at least, may be somewhat slight. Thus soft drink A, a carbonated drink with tropical fruit flavours, may be aimed at teenagers, and soft drink B, also a carbonated drink with tropical fruit flavours, may be targeted at children. But what about soft drink C, a carbonated drink with tropical fruit flavours but without any calories? This could be aimed at health- and diet-conscious adults (who tend to be younger, more affluent consumers), at diabetics and so on.

So soft drinks A, B and C, products that are all quite similar to each other, are aimed at very different consumers and each requires a trademark and logo style that is appropriate to its

■ Left These products would have no appeal outside their home markets – the brand names, though presumably perfectly acceptable domestically, are offensive elsewhere.

intended market.

The term "positioning" has been adopted to describe the process of developing services or products that are carefully constructed and crafted to appeal to a defined market in a meaningful way.

It seems certain that, in developed countries in particular, as competition increases and as consumer choice and awareness grows, companies and products will be positioned to appeal to increasingly specialist needs. Given that the design of a trademark or logo can vary dramatically according to positioning, it is obviously necessary for a designer to understand precisely the positioning of a new company or product and to reflect this positioning in his or her final design execution.

INTERNATIONAL USE

It is estimated that in western Europe more than 50 per cent of all people employed in companies work for companies with some real international component to their businesses – international sales, overseas licensees, foreign manufacturing operations and so on.

So while it is unlikely that a local restaurant or taxi firm requiring a new trademark or logo will ever use it internationally, the possibility of international use must nonetheless be taken into account in a high proportion of projects.

The implications of this are obvious. For example, it would be unwise to adopt a name that has unfortunate meanings in a foreign language or to use images or analogies that, in overseas markets, might be considered insensitive.

Equally importantly, an approach that is entirely suitable for the home market might be much less attractive in overseas markets. The logo styles used quite widely in eastern Europe – gear wheel devices are common among manufacturing and trading enterprises – can look dated and fusty in the West. Similarly, the finely honed, abstract symbols favoured by American corporations are less commonly used elsewhere.

Of course, trademarks and logos that have their roots in the home market can have real distinction in foreign markets. Don't go to the extreme of adopting a sort of "Esperanto" approach to trademarks and logos, but do remember to look out for international aspects, even if these appear to be of no interest or of only secondary importance at the outset.

DURATION OF USE

It is tempting for a designer to adopt a design solution that is in the forefront of today's fashion. But the time period over which the design is to be used needs careful consideration. A logo design for a particular sporting event (for example the Seoul or Los Angeles Olympics) or for a particular art exhibition can be voguish and of the moment. It will, after all, be used for only a short time. Indeed, the ability of exhibition or theatre posters so directly to evoke a particular year or era is much of the reason for their success as decorative objects.

Usually, however, a trademark or logo has an extended life, and clients normally seek a design approach that has a more long-term appeal. Although any design needs up-dating from time to time, few clients wish to abandon a design after a few years because it has become hopelessly dated, especially as they will have invested in it a great deal of money and effort.

PROMOTIONAL PLANS

Trademarks and logos can be used in a wide variety of applications – on letterheads, on vehicles, on products, in advertising and so on. You should take the range of likely use into consideration when developing a design. For example, a finely executed design that looks terrific on the chairman's personal notepaper may not reproduce well on waxed cardboard packing, and it may look plain silly on the side of a truck.

RANGE EXTENSION

Be mindful too of possible future developments. A logo design incorporating a dog's head for a dog food manufacturer may look great if your client sticks to dog food, but it would probably need considerable revision if he extended his product range into cat food, bird seed or other pet food areas.

LICENSING PLANS

If your client plans to license or franchise his product or service - and franchising is one of today's fastest growing businesses – this too may influence the designs approach you recommend. Complex designs requiring careful execution may quickly become corrupted when left to the tender mercies of licensees. Designs in which spatial relationships or colour schemes are not closely prescribed are also particularly susceptible to corruption. Also, and as discussed later – your client would be advised to have particularly strong legal rights in his trademark or logo if he is considering a licensing or franchising strategy - if your client builds up a franchise operation his main method of controlling his licensees may be through his trademarks or logos. If a licensee steps seriously out of line and your client terminates the licence, he would be in

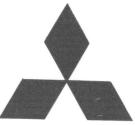

■ Left and above Gradually over the years the Mitsubishi logo has evolved from a three-tier diamond design to a design which has become one of the most widely used logos in the world, appearing on everything from traveller's cheques to aircraft.

serious trouble if he could not stop the delinquent licensee using his trademarks and logos.

So the first stage in designing a trademark or logo involves sitting down with your client for perhaps an hour, perhaps a day or more, and finding out as much as you can about the company or product, about future plans, competition and methods of use. He or she will generally have a great deal of information available and will normally be happy to discuss it with you.

FURTHER RESEARCH

Although the starting point should be a thorough briefing by your client, you should also conduct your own research. If the new logo is to be used on store fronts, go out and visit one or two of the stores in question and see them for yourself. Consider where they are sited, the distance from which they are visible to passing motorists, the types of customers they attract, the general style and layout of the stores, the appearance of the stores on either side and so on. You should also take some photographs of the stores, possibly using a Polaroid camera, as well as a few simple measurements so that you can make models or scale-drawings of the logo style on the store front. If your client has no objections, you might also ask the store manager and the sales and other staff for their views.

On the other hand, if the trademark or logo is to be used on packaging, get hold of as many examples of the packaging as you possibly can –

22b 16	this product were to become available would you be prepared to purchase it? DO NOT READ OUT.	CODE (27)	ROUTE
	renared to purchase	1	
	163	2	0 5
	Yes if not too expensive	3	
	No		
		(28)	
22c	Why is that?	(20)	
		(29)	
		(30)	
022d	IF WOULD NOT PURCHASE If you could obtain this product only at a pharmacy or drug store but not at a supermarket would you consider purchasing it? THANK AND CLOSE FOR RESPONDENTS WHO WOULD N' DISPOSABLES MEMTIONED AT Q1 THEN SKIP TO Q29).		JNLESS
	DISPUSABLES MEMORIANE ASK:	(32)	
000-		1	23b 23c
Q23a	If you were to use this product word products? Use it in current bottled or canned products? Use it instead of current products?	2	
		(33	3)
023b	How exactly would you use this product in conjunction with the current products you give to your baby?	_	
		(3	34)
			35)
			(

■ Above Market research questionnaires are designed to explore the behaviour and attitudes of target consumers in depth. They are carefully constructed so as to ensure that the questionnaire does not bias the results and so that the results can be easily assessed often by computer.

both your client's and that of his competitors. Sample the products, compare them, touch them. But at the same time you should be analytical and critical. Make a chart or grid of the major design characteristics employed in the logos of competitors. If seven out of eight major competitors use one or two similar colours, and only one of the eight is genuinely different, consider the implications of this. Is the "different" brand new and successful, or new and less successful, or old and successful? Should you join the pack or be different? Consider such issues carefully, and be prepared to justify your position to your client - he is pretty sure to crossquestion you on issues like this, and he is more likely to accept your logo design if he believes you have considered all the relevant issues.

Look too at the point of sale of all the competitive products (often, in the case of consumer products, this will be a supermarket shelf), and consider whether the existing logo designs do the job properly or, if not, what is wrong with them. Can the logo be seen properly from three or four metres away? Is the product normally stacked upright or on its side? If it is stacked on its side, should the trademark be used sideways on the pack or diagonally?

You may find it useful to prepare a scorecard of the major features and attributes and to allocate a weighting to each. You can then score all the competitive products and obtain a league table. In this way you will start to understand more fully the design issues and the design task.

But you can go further than this. You can compile a questionnaire and ask other people what *they* think about the products and their design. You may find that this coincides with your own views ... but it may not.

Of course, any information you gather your-

self can be considerably supplemented by using market research data, which your client may well have commissioned. Data falls into two main categories – qualitative and quantitative.

Qualitative market research data is normally gathered in group discussions. A trained group leader or moderator leads a series of discussion groups (known in the US as focus groups) and explores with the target consumers in the groups their attitudes, opinions, prejudices and motivations. The group leader can, therefore, ask typical consumers to try a new product or comment on a new logo design, and their reactions can then be probed in some depth: "Why did you prefer this breakfast cereal to that?" "What do you think of the colour?" "Would you pay \$x or £y for one of these?" A skilled group leader can obtain in these groups a great deal of extremely valuable data, which, in turn, can greatly assist the designer in recommending a design solution that is relevant to consumers.

Quantitative market research is familiar to us all from the "league tables" that newpapers and TV stations run at election times to show which parties have what share of the vote. Companies use quantitative market research to plot their market shares, to compare one new product proposition against another, to measure consumer response to their advertising and that of their competitors and to measure attitudes. (Petrol companies, for example, might well use quantitative market research techniques in advance of a promotion to determine whether free model cars are likely to be more appealing to their customers than a prize draw.) As its name suggests, unlike qualitative research (where the results of the discussion group cannot be quantified), the results of quantitative research are normally expressed numerically.

Qualitative research is often used when various concepts are being explored in depth; quantitative research is normally used to compare different approaches once they have developed. Both forms of research can be of considerable help to the designer of a trademark or logo in helping him or her to understand the problem in detail before attempting to develop design solutions.

However, in the new product area market research has to be applied very skilfully in order to obtain meaningful results, and much of the research that is currently conducted is of only limited value. The problem stems from the fact that it is difficult to construct research conditions that accurately mimic real life. If consumers in the USA or Britain had been questioned in detail in the early 1970s as to whether or not they would buy bottled French sparkling water, their answer would probably have been a firm "no" yet Perrier has been a great success. If the same consumers had been asked if they would spend their money on a home computer they would probably have said "no" to this too – yet millions of home computers have since been sold. So the designer does not necessarily have to accept market research data as representing absolute truth. If they do not fit with his own experience or his own investigations, or even his own gut feeling, he should challenge them. But if he does so he must muster his arguments and be prepared to defend them.

WRITING A DESIGN BRIEF

Before designing a trademark or logo (or indeed before undertaking any sort of design exercise), it is useful to draw together all the information you have obtained – from your client, your own investigations, your own experience, from market research and from competitor analysis – and distil it into a written design brief. The design brief has three main functions:

- It helps you to crystallize your thinking, sort out priorities and get a firm understanding of the precise nature of the job in hand.
- It is a useful document to show to, and discuss with, your client. You can double-check that you are both on the same track (and it is better to do this at the start of an assignment than at the end).
- It is a reference document that you can use throughout the course of a project and against which you can compare your final product.

Many designers, faced with the need to write consecutive sentences, contract a form of nervous terror. (Conversely many people who are entirely comfortable with a pen in their hands view the prospect of undertaking any form of design with equal terror!) However, you are not expected to write a detailed essay on your client's design problem or to prepare a detailed design manual. Rather, you are going to put down on paper, simply and economically, the main elements of the job you are facing.

■ **Right** The design process is a complex one and involves frequent interaction with, and approval by, the client.

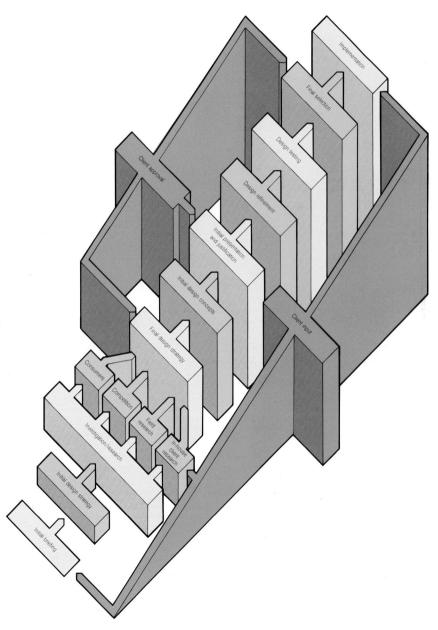

A TYPICAL DESIGN BRIEF

For example, your client is Torq Computer Systems. Based upon your discussions with the president of the company and your own investigations, a typical design brief for the Torq Computer assignment might read as follows.

INTRODUCTION

Torq Computer Systems is a newly formed company, which will sell sophisticated software programs to users of Hewlett-Packard minicomputers around the world. These programs are likely to cost from about \$2,000 to \$15,000 each. The name Torq Computer Systems has been registered in key markets, and we have been commissioned to develop the logo style.

THE COMPANY

Torq Computer Systems is a start-up company that has been funded partly by the founder directors and partly by an investment bank. It is in the process of opening offices near Boston and plans within the year to open a branch office in London. Further offices are planned for Frankfurt and Amsterdam within two to four years. Other major markets, primarily those in Europe, the Far East and Australasia, will be served by sales agents. Turnover in Year 1 is planned at almost £1 million rising to £4 million in Year 3.

THE PRODUCTS

The company plans to focus on the development and sale of software products specifically for Hewlett-Packard mini-computers. These products will be general-purpose utility programs rather than industry-specific application programs. In other words, they are aimed at helping any user operate his machine more efficiently and are not specific to particular industries.

THE MARKET

There are about 10,000 Hewlett-Packard mini-computers currently installed worldwide of the type for which Torq Computer Systems is developing programs. Almost half of these are sited in the US and Canada and about eight per cent in the UK. The remainder are mainly located in Continental Europe, Japan and Australia. Because certain installations have multiple machines, this implies a total of perhaps 4-5,000 potential customers for Torq Computer Systems.

CONSUMER ATTITUDES

There are a large number of small computer software companies attempting to sell programs in this market segment. Users, mainly medium- to large-sized businesses, utilities, government departments, research institutions and so on, are bombarded with letters, mailshots, etc. from vendors but are generally

suspicious and sceptical – suppliers fail at an alarming rate and few of the programs match up to their promises. Thus, while there is a real need for high-quality programs that really do the job they promise, and while users are willing to pay for top quality programs, convincing them is difficult.

TORQ'S POSITIONING

Torq Computer Systems will position itself as a *quality international* supplier of general-purpose utility software programs for Hewlett-Packard minicomputers.

DESIGN IMPLICATIONS

The new logo style must be:

- Capable of use internationally on stationery, invoices, advertisements, etc.
- Widely applicable as the company is *not* servicing one particular industry sector.
- High quality and reassuring because
 Torq Computer Systems is not a fly-by-night software supplier.
- *Distinctive* customers are bombarded with information from suppliers.
- Relatively inexpensive because Torq Computer is a start-up company.
- Protectable as the new logo is likely to be used widely by agents and licensees.

D eveloping the design concept

so – YOU HAVE BEEN FULLY BRIEFED by your client, you have conducted your own research and you have prepared and agreed a design brief. You have got all the background you need. There are no more excuses – you just have to get on with the design! But where do you start?

The purpose, of course, of developing the design brief is to start to narrow down the options. Even before you start any work on the design you may well know that a separate logo is not required. As the new trademark is a product trademark and will be used only on packaging, a name-only logo or a name logo in conjunction with a simple graphic device is all that is required. On the other hand, elaborate, multicoloured designs may not be acceptable to your client. He may not be able to afford them or he may have operations in countries without readily available facilities for sophisticated multi-colour printing.

Alternatively, you may have established that your client is in a business in which traditional values are of critical importance; your designs must fall broadly within the existing design and branding "culture". Innovative design solutions are therefore unacceptable.

You may, of course, already know that the business is an international one. Although it happens to have its headquarters in, for example, Norway, it likes in all its markets to be seen virtually as an indigenous supplier. In such a case, design solutions using, for example, Viking

helmets or long-ships would not meet the brief.

In other words, even before you start the preliminary design work your investigations will have helped to focus your attention on certain key design routes likely to be particularly appropriate and productive. Although the creative options that confront you are still practically limitless, you are seeking design solutions within clearly understood and agreed guidelines. You are not wandering aimlessly.

VISUALIZING THE DESIGN BRIEF

Torq Computer Systems was the subject of the outline design brief in the previous chapter. Let us take this project further and use Torq Computer Systems as a detailed example of how we might visualize a design brief.

Torq is a start-up business in a competitive high-tech and potentially international business. The design needs to work hard to achieve "standoutability" in a tough, competitive business, but it cannot look insubstantial and fly-bynight; nor can it be lavish and expensive as funds are tight.

The new trademark and logo will be used on stationery, brochures, manuals, advertisements, computer tapes and, at a later date, possibly on service vehicles, exterior signs and so on. However, a critical and immediate requirement is to devise something for the company notepaper, and this would seem to be a good place to start from a design point of view. A solution that

■ Above You have a design brief for Torq Computer Systems but where do you start? Perhaps with the obvious – an image of a computer. Such a traditional association of ideas may seem out of date but it still might be worth pursuing.

works well on stationery should be capable of ready translation to other applications.

Let us consider the type of approach we should adopt. It would obviously be possible to develop both a graphic style for the corporate name and a separate logo, but there seems little point to this. After all, the name Torq is short and memorable, it can be read at a glance, it is dramatic and distinctive, and it is not so cumbersome that it could not be used in its entirety in all conceivable applications. It would seem sensible, therefore, to develop a design solution focused around the name alone without a separate logo.

What does Torq convey as a name? It is certainly different. It ends in a distinctive and unusual q, it has only four letters, and it is a homophone for *torque* (a term used in physics to describe rotational forces) and *talk*. It is a distinctive, even intrusive name and helps greatly with the task of achieving "standoutability". The designer should therefore seek to enhance the inherent distinctiveness of the name and focus the design solution on the corporate name.

Torq's business is all about computers. What images do computers conjure up? Some years ago, flashing lights and spools of tape would have been an obvious choice, but now we are in the age of the PC, the diskette and the miniaturized keyboard. Even giant business computers have been reduced to anonymous grey boxes not unlike upright freezers. However, it might be worthwhile considering a more traditional association of ideas.

One approach could be to focus on the appearance of the keyboard with the letters Torq depicted as if they were the keys of a typewriter. Although such an approach may look quite attractive and you may not recall having seen it before, it is scarcely credible that no one else has

ever come up with this solution. Save it in case nothing better occurs to you.

If you look at a standard keyboard you will notice that all the letters of the name appear on the top line, although in the wrong order. You may be able to build on that. But this solution is a little clumsy and forced. It is also rather obscure – a sort of designer conceit – and has also been done a few times before, mainly in the 1960s and 1970s. In any case, you cannot simply leave gaps in the top line of the keyboard – you would lose the idea altogether.

If you decide to pursue this approach, you must find a way of *subtracting* the letters needed for the logo from the top line (which almost everyone, especially typists, will recognize). You could perhaps experiment with colour, although it all seems rather laborious. Perhaps this is an idea you should come back to.

Above Would you recognize this as four letters taken from a keyboard? it is a good idea, but surely someone has thought of it before. **Below** The letters TORQ appear on the top line of the keyboard. But there are problems – the order and the intervening letters

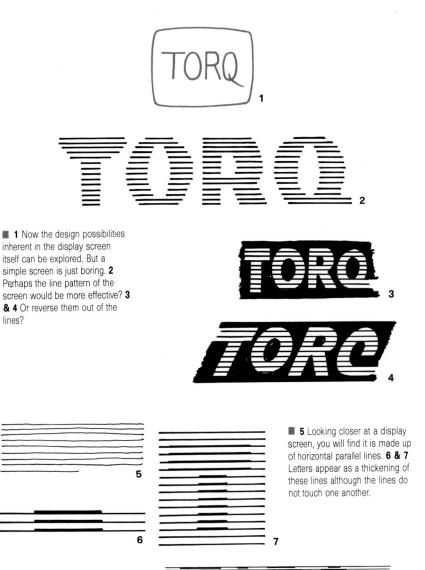

■ 8 Exploring this idea, try arranging the lines in a denser pattern. 9 Now, vary the typeface and the width of the line. As with so many ideas, this development gives rise to another idea - the original "computer", the abacus.

lines?

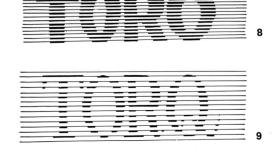

If the keyboard approach does not work, it might be worthwhile trying a computer display screen (1). A simple screen would look extremely boring, but you might form the letters themselves from the line pattern of the display screen (2), or reverse them out of the lines (3), even changing the type to italic to make the design appear more dynamic (4).

If you are still dissatisfied, go in a little closer and work out what is happening at a more detailed level. The screen is made up of hundreds of parallel lines (5). When a letter is put up on the screen, parts of certain lines are, in effect, being thickened, although no line will actually touch the ones next to it (6, 7).

Draw the word Torq in this style and you will probably notice two things (8). First, the letters do not need to be in block capitals. It would be quite possible to use a fairly thin, serif face as long as the tail of the Q did not go below the line. Second, the thickened lines do not all have to be the same weight. If you want the Q to stand out, use a typeface in which the thickness of the letter form varies (9). With modern printing techniques reproduction should be simple.

Next you could try a different typeface and more broken lines, and you will see that, especially where the letters are thin, there is a sort of on/off/on/off effect, reminiscent of the basis of computer logic – the switch (10). This, in turn, might make you think of associating this computer company with the earliest of all adding machines – the abacus.

Your first attempt might look as much like a panel of lights or a baby's toy as an abacus (11). You might want to give it a little perspective, remembering to keep the bottom flat so that the type can be lined up (12).

As well looking more like an abacus, this con-

cept also has those qualities of "approachability" that are of particular interest to your client. However, it is far too complicated – the T alone requires 81 little balls. Perhaps you could try a design that, although much simpler, is still recognizably an abacus by reducing the number of balls (13). Even so, the "framework" of the letter T will probably be so complex that the purpose of the design gets almost totally lost.

Now that you have stylized the "abacus" approach, it is almost possible to see in it a TV screen. We are all now familiar with the use of computer graphics to "manipulate" the titles of TV programmes and so forth. You may want to extend this idea and, in effect, to get the computer itself to design its own logo. If you were to give it the fixed points (14), the computer could rotate them in space, perhaps even twisting them to give a "torque" effect (15).

Such a logo, while interesting, could be seen as more appropriate for a computer animation company than for a computer software firm, but this is debatable. This logo would probably work best if photographed from the TV monitor so that the little distortions caused by the pixels on the screen could be picked out.

Some wonderful things are being done with computer animation, and the introduction of this concept could lead you to consider whether it might be possible to come up with some other computerized images – a computer rendition of the "Mona Lisa" (a striking and recognizable symbol shown in a state-of-the-art fashion) or a beautiful computer drawing of a tulip, for example. However, these would be extremely complicated to print, expensive to produce and could very well date in just a few years. They would also be totally abstract logos and would compete with the name Torq.

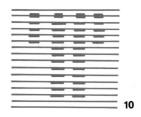

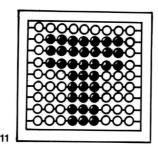

appropriate than the abacus and it is an image which is comprehensible to the layman. 11 It is a case of working round the problems. This looks more like an abacus but the T is almost lost. 12 Try putting the image in perspective, but keep the base horizontal so that the type can be lined up. 13 To simplify the idea, here the "heads" are reduced to 30. But the design is still not clear.

■ 14 Perhaps the computer can take over some of the work. By giving it the fixed points, the image can be manipulated. 15 Here the T has been rotated in space.

■ 1 & 2 Torque means a twisting force so this concept could be explored typographically. The tail of the Q lends itself to an intricate flourish but it is not very appropriate.

■ 3-5 Another way of suggesting the twisting action might be through an abstract design. The spiral fits this requirement and the double spiral (5) introduces the idea of mutual interaction.

■ 6-10 Diverging temporarily, it may be worth pursuing the idea of interaction with inter-connected shapes. Nothing which grabs the imagination appears; it is a path many have trodden before.

Having considered the visual input that computers can provide, you should start to look at some other solutions. First, the word Torq. The letter Q is one of the most elegant of letters and, as used here, without the final "ue" is a particularly strong one. This could lead you to a typographic solution (1).

However, such an effect, while elegant, is not very "computer appropriate". If this were to be the final choice, you would have to simplify it, and there is also the problem that the Q might read as O (2).

A third possibility is to apply visually the concept of "torque", a term used in mechanics for a twisting action. Different forms of spiral might suggest themselves to you (3,4), or you might even look at a double spiral to denote interconnectedness (5). The double spiral may have too many connotations of the double-helix structure of the DNA molecule and, as such, might be better suited to a bio-tech application.

The idea of "connectedness" is, however, interesting, and it could suggest to you a range of inter-connected shapes and symbols (6–9). Many of these will look bland or abstract. A visual metaphor for "mutual interaction", such as two Js or hockey sticks on their sides, is also bland and meaningless and has probably been done a thousand times (10). (German trains? Swiss buses? Chinese airplanes?)

More interesting is the idea of using parallel

lines to make a letter (11). Although the letter does not work too well in a rectangle (12), it is much more successful reversed out of the circle (13). This says "mutual interaction", it has the parallel lines associated with the TV monitor, it has the T of Torq, and it has impact. It may not be the most beautiful logo ever, but it works.

Even so, the T in a circle logo looks a bit too like Talbot Motors, or a telecommunications company or the Indian company Tata, which builds trucks and just about everything else. So try combining it with one of the earlier notions – the thick and thin lines (14). This pattern, however, is too regular and fights with the circle, which, in turn, tries to distort the fine lines. The design really belongs in a rectangle.

You have now reached the stage of having four designs that are worth taking to the next stage: the line solution; the abacus; the computer T and the T in a circle.

THE LINE SOLUTION

The entire name Torq features in the logo, so it is necessary only to find a place for the words "Computer Systems" separate from the logo. The typeface should ideally be a simple, straightforward one as this logo is quite complicated. This leaves two options: the same typeface as in the logo itself, which does lend a certain harmony to the result, or a simple inoffensive sanserif face, which has the effect of highlighting or "making special" the name in the logo. Let us assume that you chose the latter.

The next problem is where to put the line or lines of "Computer Systems" and to decide how thick and how condensed the typeface should be.

The logo is symmetrical and balanced, so centring the other elements of the name is a good

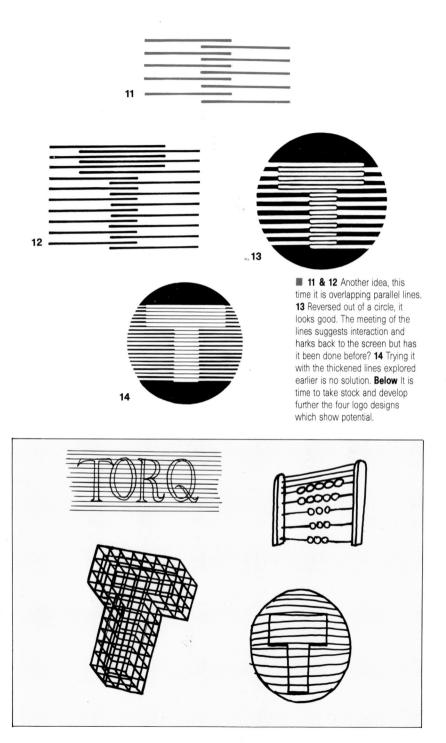

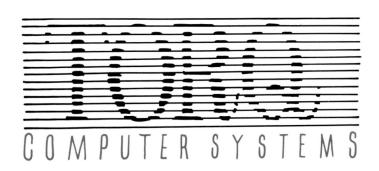

■ 1-6 With the line solution, the full corporate name has to be integrated with the logo. A simple san serif typeface will allow the name to stand out but questions of the size and weight of the type and the placing of the words must be faced. Logo 6 is confusing as there is tendency to read from top to bottom. In 2 and 3 the words do not align with the logo. Of the rest, 4 appears coherent and the balance of the logo style is retained.

idea. It is also a very busy logo, so it is a good idea to take the address details away from the logo. Possibility no 6 should be discounted as people always tend to read from top to bottom even if the middle word is much the strongest. Options 2 and 3 do not work because the words "Computer Systems" do not align with the Torq logo. Of the rest, 4 is probably the most satisfactory because even when the logo appears very small, as it must on, for instance, an envelope,

the words "Computer Systems" would still be legible while the coherence and balance of the logo style was retained.

Now that you have a possible new logo, you should try it in various ways on a letterhead. You can see that it works well in all these applications, although 7, 9, 11 and 12 are probably the most pleasing – 8 is somewhat askew, and 10 is somehow top-heavy and rather inelegant.

■ Above Having arrived at a possible new logo, the next decision is where it should appear on the letterhead. A good logo is sometimes more forceful standing on its own. 7-10 above explore the various possibilities. Otherwise the address and other information required can be integrated as in 11 and 12.

4 TORQ COMPUTER SYSTEMS

■ Above With the abacus design, the full corporate name has to be integrated. It seems to work best when the abacus sits on a single line of type. Right There are the usual options for the letterhead. In this instance centreing the logo at the top of the page seems the natural choice.

THE ABACUS SOLUTION

As yet there is only the visual portion of the logo, and you have still to find a style and place for the full corporate name.

Of the possible styles it is easy to see that solution 2 works best. Placing all the type in a single line gives a base or platform on which the abacus can stand. The typeface is however a bit fussy, especially as the abacus itself is already fairly complicated. Try a version with a simpler, sanserif face. It needs to be fairly condensed to give the line enough depth to match the frame of the abacus, and make it bolder (4).

Now that you have a possible form of the new logo, try it on the letterhead. There doesn't seem

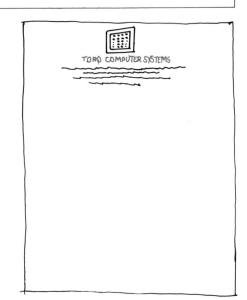

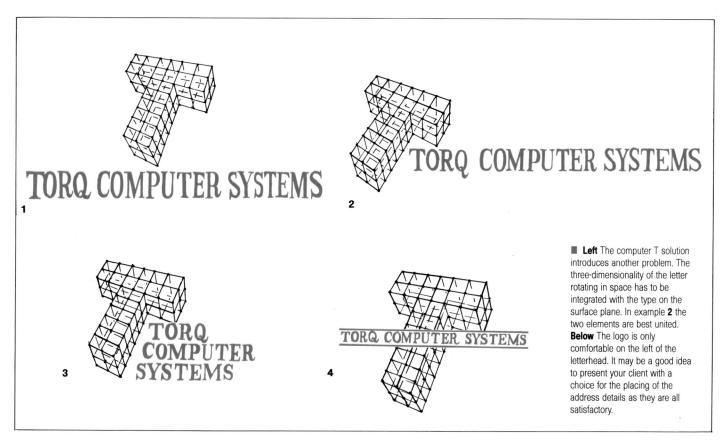

much doubt that it should be centred, so the letterhead design is fairly straightforward.

THE COMPUTER T SOLUTION

There are four possible formats with the computer T logo, and of these 2 is marginally the best. The line of print tucked under the cross-bar of the T is pleasing, and there is a certain dynamic tension between the two elements that is missing in the others, particularly in 3. The blockiness of the T also fits well with the contrasting serif face. Now look at a letterhead.

The design calls for the logo to be placed on the left of the letterhead, so the only other problem is where to put the address details.

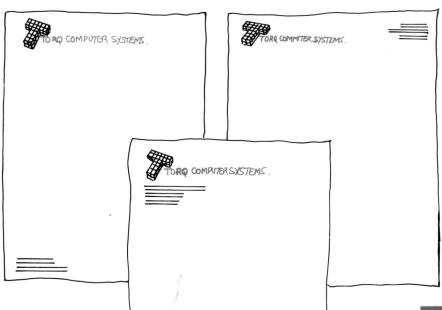

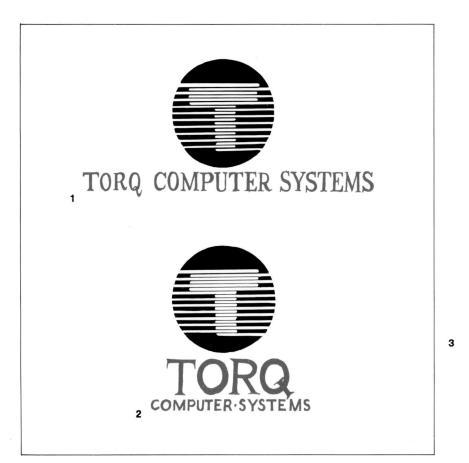

■ Above In solution 1 the complete logo can be taken in at a glance. In 2 the eye is drawn to the word TORQ and confusion results. Right This logo with its symmetry works best in the centre.

THE T IN A CIRCLE SOLUTION

It should be relatively easy to reconcile this logo design with the typestyle. A serif typeface will contrast with the blocky and high-tech T logo, and of the two alternatives illustrated, 1 is preferable, as there are only two elements to the logo, as opposed to the three separate elements evident in solution 2.

When you come to the letterhead, the logo really needs to be centred. Solution no 4 seems to be the more balanced of the two.

■ Left It is time for decisions to be made. Here are the four quite different design solutions for Torq Computer Systems. But which will you recommend to your client? All four solutions broadly meet the brief and are attractive and appropriate. Looking at them again, however, perhaps the T in the circle is a little over-familiar and the abacus is still reminiscent of a baby's toy. Either the line solution or the computer T versions are, therefore, to be preferred.

Case studies: hypothetical

■ The client is a group of realestate agents specializing in the construction, sale and letting of holiday properties. First, we must look for an image reflecting the up-market and stylish nature of this venture. **Right** is this your image of a beachfront property? Or is it more suited to a holiday brochure or an advertisement for rum?

IN THIS CHAPTER we will look at some typical trademark and logo design projects. All the examples are hypothetical, but they are closely based on actual projects. The procedures and thought processes have of course been somewhat telescoped — each example could otherwise occupy a whole book — but the examples are typical of the kind of projects that any designer working in this sector is likely to encounter in the course of doing his or her job.

■ Right The sun setting on a calm, tropical sea is an attractive image. But is it too languid for a beachfront property company?

■ **Right** By focusing on a detail of the beach, the sense of scale important in this logo is lost.

BEACHERONT PROPERTIES

The client is a loosely-knit association of realestate agents specializing in the construction, sale and letting of beachfront and holiday properties. The association consists of independent companies based in California, Florida, Long Island, the Caribbean and southern Spain. The association has no formal structure or rules. Each member of the association refers clients and leads it cannot handle itself to other members of the association in return for a commission on any sales; they also do some joint advertising and promotion and share the costs. Otherwise they are totally independent businesses. However, even though each member of the association trades under its own name, all of them have agreed to adopt a common logo style on their notepaper, on brochures, on their offices and on advertising and promotional material. They wish to project a certain uniformity and coherence but not to give up their independence. Our job is to develop the new logo style.

The beachfront and holiday properties in the locations with which we are concerned all share certain common characteristics: they are all expensive and high-class with a stylish, up-beat image. It is clear that our logo must reflect this image and that cost is less of a factor in the choice of logo than quality. So we can assume from the outset that we can use full-colour reproduction.

So, where do we start? We could of course devise an abstract symbol or use a globe device (banal!) or develop a logo based upon, say, the silhouette of an Elizabethan sailing ship (images of pirate treasure?). But to do so would, we think, be slightly absurd. After all, here we have a business that is rich in powerful and evocative images which are meaningful to all of us, even if we have never been near the ocean. We can afford therefore, to be direct in our appeal and can reject abstract solutions.

Let us first try therefore to find an image that is evocative of living by the sea. Of course, due to the geographic spread of our client's activities we must try to develop a widely applicable, universal image.

All of the images shown here are attractive, but one or two have obvious drawbacks. For example, the member of the association located in Long Island might not be too pleased with the palm tree logo (left top) as palm trees are not common on Long Island! The seagull image (right) is rather too reminiscent of a vacation tour

- **Above** Seagulls are a universal symbol of the seashore. As a result, however, it is an overworked image.
- Right Dunes with dune grass allow a more universal, yet less banal, image than waving palms and dramatic sunsets.

■ Left With the introduction of the seagull, the symbol becomes better balanced. But still the image does not put across the full range of the client's business – particularly the aspects of construction and sale of beachfront property.

Right Now we are getting closer. What could represent a home by the shore better than a shell? But no, a little private research proves that the notion is rather esoteric. **Below** The image is made more relevant when associated with the hermit crab who is constantly moving from one "beachfront" property to another. But now the image is perhaps more suited to a fish restaurant.

■ Above A window to frame the beachfront view introduces the concept of a house or home by the sea. Right: But the open door version is better. It is much more attainable and approachable, making it an acceptable solution.

operator and is a little remote from the world of property. Indeed, most of the images are too related to *holidays* and insufficiently related to *homes* and *property*, except perhaps the shell (left).

A shell is home for a small creature and is found only by the seaside. We could take this theme a step further – the hermit crab makes its home in a discarded shell and as it grows moves into a larger one. Could this be a suitable image for beachfront property?

It is an apt notion and an elegant encapsulation of the concept of beachfront property. Unfortunately, a little research showed that no one but the designer made the connection: some people found the concept attractive but abstract, others thought it would make a great logo for a wholesaler of seafood or for a fish restaurant, and a few found the image of a crab just a little off-putting.

What this exercise made clear is that we are talking about a *home* by the seaside and not just about generalized seaside values. So why not use a window device with one of our seaside views framed within it? This conveys the image of a home or building but links it directly with the seaside.

This is not only attractive but also does the job. It communicates clearly the client's business, it is universal in its appeal, it is highly evocative, and the window frame makes a useful frame for the logo.

But we could improve it. The glazing bars of the window somehow prevent us from achieving the reality of a beachfront home: the image is tantalizing but we cannot reach out and embrace the image. We are in an attractive prison. So why not have a door opening out onto a wonderful seascape? This image is welcoming, approachable and obtainable. It is also attractive, universal and upbeat. An elegant solution.

ANTIQUARIUS

We have been commissioned to design a logo and packaging for a range of specialized stains, glues, varnishes and polishes used in the restoration of antique furniture. The products, known as the Antiquarius range, are for sale primarily in North America and the UK, but the market is fairly restricted – such products are used mainly by professional restorers and by skilled amateurs – so we have to keep the costs down. We do know that an attractive presentation always helps to sell products, so can we design an attractive logo and range of packaging in only two or, at most, three colours?

The initial range consists of some 15 main products and at least one of these products, the wood stain, has a number of different variants – light oak, dark oak, mahogany, walnut and so on. It is clear that we cannot develop a separate "personality" for each product or the result would be anarchy. Rather, we have to develop a single "persona" that will be applicable to the entire range but in which we can clearly differentiate a wood stain from a varnish, and a glue from a polish. It must also be possible to extend the range and introduce new furniture restoration products without damaging or distorting the overall concept.

An obvious way to do this is through the use of a simple colour coding system – the logo itself would probably always appear in precisely the same format but stains could have labels with a tan background, varnishes cream labels and so on. We could then distinguish the different stains or varnishes by the use of small stickers on the cans, which are standard, "off the shelf" sizes because our client's volume is not sufficiently large to 'allow for any non-standard packaging ideas.

A Wash hand . Kand. A Pot Captonia Antoren Jalle A Lady's Calinet and Writing Falle

■ Eighteenth-century furniture designers produced detailed catalogues of their work and these have been used by craftsmen ever since. **Right** These five engravings, taken from such a handbook, are entirely relevant to our client's range of goods used to restore antique furniture. Furthermore, they are out of copyright and, therefore, inexpensive.

The typeface for the logo needs to promote the concept of antique. An unfussy banner combined with an old serif face will do this. Typeface 1 was designed by George Trump in 1950, while 2 was designed in 1929. Typeface 3 known as Fry's Ornamented, was cut in 1796 by Richard Austin.

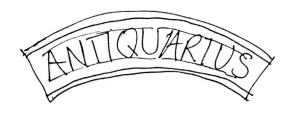

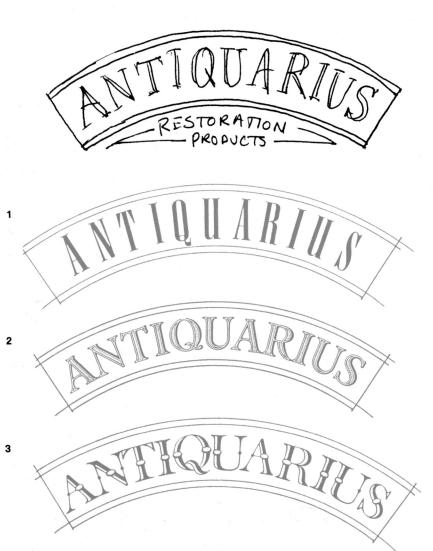

That, then, is the job we have to do. It has three main elements: we need a trademark or special logo for the Antiquarius name; we need to integrate this logo into an attractive and appropriate label or pack design, perhaps incorporating a pictorial element; and we need to develop a system to differentiate among the various products and to identify and describe each product.

As the cans will be existing, standard shapes and we are working to tight budgets, an obvious solution is to use stick-on labels incorporating a panel for the logo, an illustration and a panel for the product descriptor. The precise shade of, for example, stain can then be indicated on the can by a sticker.

Even given these tight parameters, there are dozens of possible approaches. We are restrained from many of them by shortage of funds, so our illustrations, for example, will have to be inexpensive. Although we could use an illustration of a craftsman at work, we are particularly attracted to illustrations of antique furniture. It would also be great if each pack carried a different illustration, provided of course all the illustrations clearly formed an integrated series.

This should not be a problem. Many books contain beautiful steel engravings of period furniture, and these engravings are out of copyright. So, for the price of a few books, we have a selection of fine illustrations that would cost thousands of pounds were we to commission them today. Also, the period style of the illustrations is entirely appropriate.

Now let us turn to the logo. The proper title for the range of products is Antiquarius Restoration Products, a bit of a mouthful. Why not put the name "Antiquarius" in a curved banner? This, combined with a venerable serif-face, would give an immediate "old" feel. The banner should not however be too fussy. We could also place the words "Restoration Products" under the banner to "square off" the logo.

Let us now combine this logo with an illustration and a *descriptor* (a product description and statement) to form an integrated label design. You will see that we have broken the border with the logo to give the logo greater prominence, and we have made the product descriptor subordinate to the logo, although it is still fairly prominent and readable. We have also used the same typeface for the descriptor as for the words

"Restoration Products" to preserve unity.

Having now established a logo and a broad format we have arrived at clearly defined parameters within which to work up the final designs. We must bear in mind, however, that the Antiquarius logo will remain precisely the same in each instance, and that stains, glues, varnishes and polishes will each have their own illustration and their own colour scheme. Clearly the colours chosen should be integrated together and fit with the logo, and the four illustrations should all clearly form part of the same family. A possible solution is illustrated on this page.

■ **Below** By combining the curved banner with the attractive original steel-engraved illustration, a robust but appropriate logo design evolves. A simple colour-coding system distinguishes the individual product ranges.

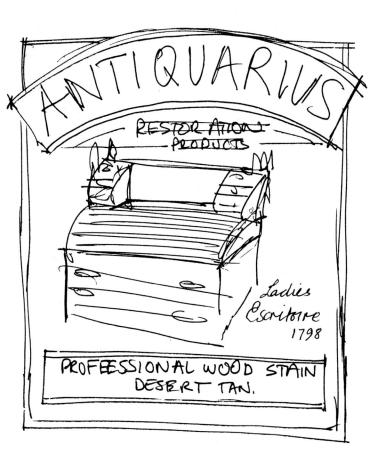

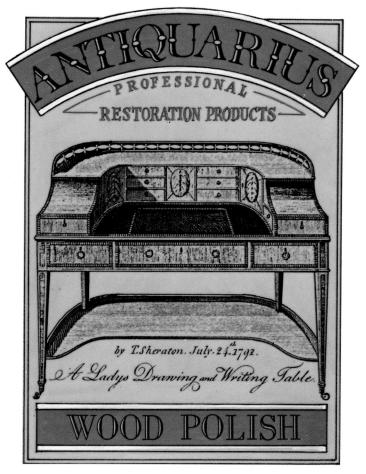

COMPTON PRODUCTIONS

Our assignment is to design a logo for a company called Compton Productions which makes TV commercials. The company was started in the early 1960s in Sydney, Australia, on Compton Street – hence the name. It is now opening its first overseas office in Los Angeles and feels it is time it adopted a new logo.

The new logo will be used on letterheads, business cards, and envelopes and on the outside of video cassettes sent to advertising agencies to promote the company. No other uses are currently envisaged, except possibly signage. The logo should be clever, upbeat and smart so that it appeals to art directors and creative people. It should also appeal in Europe – an office in London is under consideration.

Hitherto the company has not really used a logo – it has simply used its name on notepaper in a workmanlike but rather undistinguished typeface – so there is no existing logo to modify or up-date. There is also little visual or emotive content to the name Compton – it is worthy but rather bland – so let's explore the concept of movie-making. Clapper-boards have been done to death. Directors' chairs are also very hackneyed. Megaphones may be reminiscent of Cecil B. de Mille, but they conjure up notions of *sound*, and movies are essentially *visual*. An Arriflex film camera is much too obvious.

What about a director, complete with plusfours and megaphone? The image could be attractive, provided the quality of the illustration is high and in the style of the 1920s. It is certainly worthwhile taking this idea further later in the project to see how it works out. It has the disadvantage that the logo will be multi-coloured and therefore expensive to print, but it might be worth it for the sake of the company's image.

■ **Above** But it may still be possible to present a familiar image in a fresh way. If we show

the Arriflex camera in a pool of light, we come closer to the image of a film production company.

The client is not, after all, in a particularly costconscious business, and there would be no problem with quality printing in Sydney, Los Angeles or London.

Another obvious idea to explore is film. It is, really, all about light and shade. What about a pool of cast light or a spotlight or a movie camera shadow? We could print the shadow a grey colour for the letterhead and leave the spotlight the white of the paper.

■ **Above** The clapper board, the director's chair and the Arriflex camera are all somewhat overused images.

■ Above The spotlight itself is another visual image which is worth exploring. We can, for example, hang it from the top of the page and use yellow light to provide richness and interest.

But what about a spotlight itself? Perhaps if it were hung up from the top of the page, the spotlight, which is normally black, could be printed in grey and the light in yellow.

This solution is by no means bad, but it is not as good as some of the others and it is also a little hackneyed, but the pool of light idea is appealing. The lettering could be in a pool of light and cast a shadow. Or we could put shadowed white lettering on a grey background. This is somehow reminiscent of old movie titling. In fact, we could do the whole name in that style.

You will see that we have by this stage barely started to explore the many routes we can take to develop a new logo, but already rich and attractive alternatives are emerging.

It is also apparent that whereas it might at first appear that we are wandering aimlessly, in fact the creative process is a fairly systematic one that has as its boundaries clear strategic and functional considerations.

■ Above The name COMPTON is not particularly dramatic but it is solid and reliable. Perhaps we can present the name in a more exciting way by representing it in a pool of light so that the letters cast shadows?

Below Shadowed lettering on a grey background is reminiscent of old movies and the appeal of old movies is strong and universal.

COMPTON PRODUCTIONS

CONTINENTAL COFFEE

We have been commissioned to design a logo for Continental Coffee Corporation (in Portuguese Corporação Continental do Caffeis), an exporter of bulk coffee from Brazil to the rest of the world. Our client is based in Rio de Janeiro but has overseas offices in 12 countries including the US, West Germany, Holland and Italy. It wants an attractive logo that will reflect its standing as an important international company. The logo has to be fairly simple and flexible, as it will be stencilled on to crates and sacks and painted on trucks, containers and ships. It will also be widely used on notepaper, financial and shipping documents, invoices and so on.

The first consideration was whether an abstract logo might not be suitable – a clean, simple device like those used by Mitsubishi or Rockwell International perhaps. In fact, we do not need to be entirely abstract as our client is involved only in coffee and, as a quasi-governmental body, has no possibility of moving into other fields. We can therefore focus exclusively on the current name (perhaps something related to the three Cs of Continental Coffee Corporation) or on the company's business – coffee.

The three Cs idea was rejected early on, partly because in certain languages – German, for example – the translation of the corporate name does not begin with three Cs. The new logo would appear to be somewhat obscure in such languages. More particularly, the imagery of coffee is so rich and evocative that to reject a coffee-related logo in favour of a more humdrum approach might be considered perverse.

So, what are the wonderfully evocative images that coffee conjures up? Blue mountains, rows of terraces on steep hillsides, blue-green bushes with bright scarlet berries, peasants beating overloaded burros, coarse hessian sacks, glistening rivers of dark beans, the wonderful aroma of freshly roasted coffee... There are also all the images connected with making and drinking coffee – roasters, grinders, *espresso* machines, mugs, cups, the surface spiral of cream in a cup of coffee....

However, we must remember that the logo has to work on anything from a jute sack to the chairman's personal notepaper. It must, therefore, be simple but flexible. Moreover, it seems highly unlikely that the new logo will ever be presented to the end consumer, either on the product or through advertising or promotion.

In a more abstract form, the coffee bean can be represented like this.

Even as a symmetric split oval, the image is retained.

Rendered as a perfect circle, the image is lost. It looks more like an aspirin.

Let us return to the oval and make it more interesting.

The trick is to make it distinctive by combining it with another element.

The bean within the berry idea borders on the esoteric and looks more like a traffic sign.

Playing around with the solid circle does not seem to help either.

Perhaps the circle is wrong. No, now it looks like a peach.

This design appears equally strange – the flag of a little-known "coffee dictatorship"?

This idea tries to put across the international nature of the organization – too pretentious.

Let us try a few alternatives. No, this looks like a flower and has no impact.

A more pleasing design, but a trifle obscure.

A flower again or necklace: this idea does not seem to work.

The suggestion of movement in this design is inappropriate but it is a useful idea.

■ Above The roasted coffee bean is a familiar image yet it is difficult to develop a logo based upon such a simple shape. Left In some cases the effect is destroyed or the logo is unattractive or faintly absurd.

It has quickly become apparent that few people know that coffee berries in their natural, unroasted state are, in fact, red; so a representation of the berry in this form is not an option. But everyone knows what a roasted coffee bean looks like. It might be rendered in a more mechanical and simplified form or even in a perfect circle.

The circle idea makes it look like an aspirin or a multi-vitamin tablet, so let us return to the oval. Making it look more interesting loses the coffee bean effect. The trick is going to be to find some way of making it into a logo by combining it with some other element or elements in order to make it both interesting and distinctive.

Somehow a coffee bean by itself does not work, but a logo showing lots of beans is altogether more realistic and better conveys the image of "bulk". But somehow a circular logo does not fit with the oval shape of the bean – it would work better in a square – and the simple and attractive two-colour logo will also work in black and white.

So let us halt here for a while and turn to the problem of the lettering. This is a considerable one, and we shall have to find a simple scheme as the design will be implemented in a dozen countries and in at least six languages on everything from a letterhead to a ship.

Helvetica would be an attractive choice of typeface; it is available everywhere and we can devise a simple proportional system based on fifths which is easily communicable by diagram. After all, there will surely come a time when the logo is going to be reproduced by an illiterate sign-painter!

You will already see how one logo design solution is emerging. Of course, in practice the "beans in the square plus Helvetica typeface" approach would represent only one route that should be explored. It might turn out to be the designer's preferred solution and it might even be selected by the client. On the other hand, by the time all possible routes have been explored and worked up, it might not even get on our shortlist of solutions.

■ **Below** In everyday life, we are used to seeing coffee beans *en masse*, not individually. A logo embodying this concept is altogether more pleasing. Contained in a circle, however, the shape conflicts with the oval beans.

■ Far left This design shows more promise. Dark, shiny coffee beans in a square box make for a logo design which is balanced, appropriate and has wide appeal. Left A Helvetica typeface for the lettering looks good and is obtainable in most countries of the world. Clear rules for usage of the logo and the typeface, based on fifths, will allow ready implementation and prevent corruption of the design.

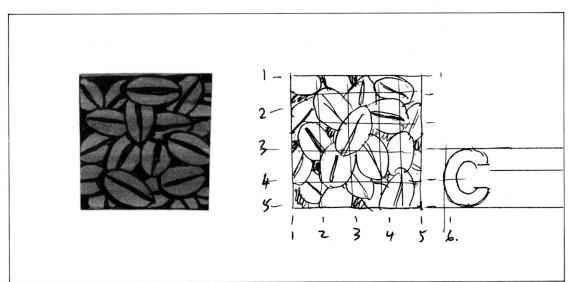

VISTA

Our client, a major British retailing group, is planning to develop a chain of medium-sized retail stores specializing in products for the elderly. The stores, which have on average an area of about 1,000 sq m will be located in good, though not prime, positions in main cities and in areas with a high proportion of retired people – the south coast of Britain, for example. The concept will be launched in the UK, and if it is successful, it will be licensed or franchised overseas. Already, investors and retail groups in Holland, Scandinavia and the US have shown interest in the idea.

The background to the project is this: over 15 per cent of the British population is aged 65 years or over, and approximately 7 per cent is over 75. The situation is similar elsewhere in northern Europe, and in the US, which has an elderly population of over 12 per cent - a figure that is rising fast. The requirements of the "young elderly" frequently do not differ greatly from those of younger people, but the very old, those aged over 75, often require markedly different products, which, at present, are not readily available. These items include mobility aids (walking frames, wheelchairs and so on); clothing that is smart and comfortable but has special fastenings for people with arthritic fingers and failing eyesight; appliances such as spectacles, hearing aids and magnifying lenses; leisure products such as large-print books, special gardening equipment and holidays, special furniture, bathing aids and so forth.

Our client's plan is to develop a chain of stores specializing in good-quality, good-value products for the elderly. These stores will be friendly and approachable and will not have the "stigma" of age attached to them. They will have

wide aisles, non-slip walk surfaces, handrails, seats and good lighting; and the staff will be knowledgeable and well trained. The stores will also sell mainstream products such as toiletries and greeting cards, and each store will have its own pharmacy.

The name for the new retail chain, Vista, was chosen by our client after much deliberation. It seems that many of the current images of old age are, unfortunately, of misery and despair, and our client was determined not to portray old age in this way but rather to give the new stores a fresh, lively image. Names such as Grannycare and Autumn Days were quickly abandoned, and Vista was chosen because it is largely abstract but has associations of "wider horizons" and of breadth. It is also quite international and has a distinctive and incisive first letter. The plan is to use the name Vista both as a corporate name and as a brand name on many of the products sold in the stores.

In developing a new logo style, the first question to be addressed is whether a separate, free-standing logo is required or whether the name Vista, in a stylized form, can function as a trademark. In fact, there seems little point in developing a separate logo. The name itself is short and snappy and can probably be used in its entirety in all likely applications, and we will, in addition, have a sufficiently large job on our hands to get the new name established without having to establish a new logo as well. If, at a later date, a separate logo is required, it could be developed at that time; it may, for example, be possible to take the stylized V out of the logo and use it by itself in certain applications.

The more immediate symbols of old age – walking sticks, wheelchairs, old folk with white hair, dentures – are obviously out of the ques-

■ Above The name VISTA is short and balanced yet has an appropriate core of meaning. In this instance, therefore, a separate logo is not required.

■ Above Exploring the graphic possibilities of a name like VISTA can be fun, but some ideas clearly do not work well. The heavy V and A in this example are

symmetrical but not easily read. **Right** The red dot reminds us of the sun, perhaps suggesting a vista or view.

tion, so let's start by looking at the name Vista. It is a balanced word, especially when written in capitals: it has a pleasing symmetry, and the first and last letters are almost the same shape but inverted. In fact, the final A does not really need a crossbar in order to be read.

The first stage is to try some simple graphic treatments. The example that includes a red dot on the I is quite attractive; it brings to mind a sun or a sunrise, an image that is not inappropriate. By separating the shadows from the actual lettering, legibility has been improved. Although this solution is not bad, it does look a little like a travel agent's logo.

Making the V and A more abstract does not really work, mainly because the word is now difficult to read and because the coherence of the name is destroyed – two strong shapes are joined by weaker shapes.

Even when the symbols are simplified, the V and A are still too strong, although, paradoxically, they somehow disappear, leaving us to read the name as IST.

A sort of *Ben Hur* lettering with strong colours is completely wrong – it looks like 1930s Hollywood.

A large V followed by smaller lettering is only slightly better. It looks as if a seagull has got in on the act!

A more abstract design superimposed on a V

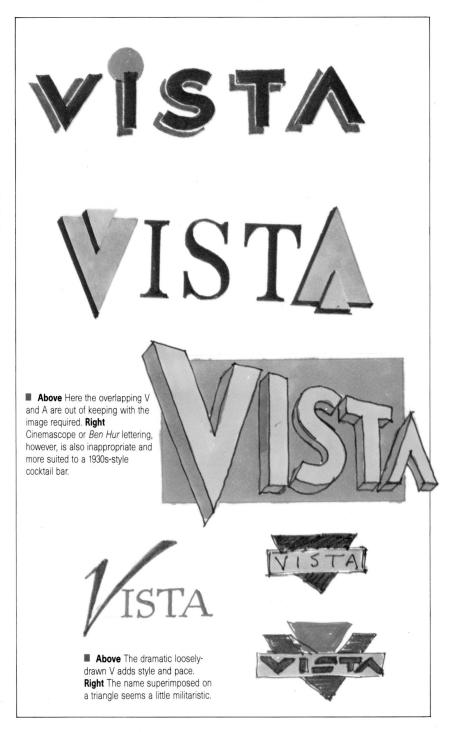

VISTA VISTA VISTA VISTA VISTA VISTA

■ Left Simpler, less contrived versions of the name are easier to read and fresher. These treatments are all, however, very "late 1980s".

■ Below Whenever the first and last letter are distorted, the spacing stretched or the lower case is used, coherence and impact is lost.

KSH

Vista VISTa Vista VISTa

VISTA VIST

Vista

■ Top Such simple typographical flourishes attempt to create a more integrated, harmonious logo style. But, although it breaks away from a stylized, typest name, it tends to lose impact. ■ Above Despite our earlier intentions, we are tempted to take another look at the lower case. But we were right, this logo is rather weak and insubstantial.

■ Right When the name VISTA is combined with images of the landscape – the sky, earth and sun – some interesting possibilities emerge.

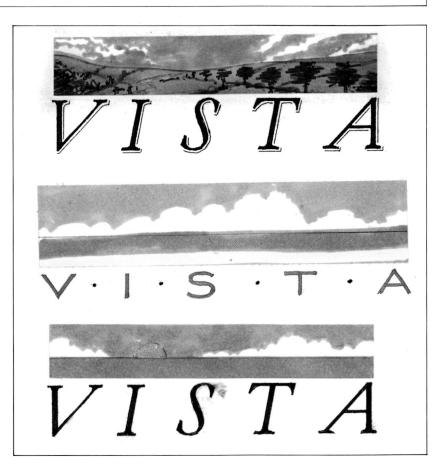

looks a little militaristic – it could be a shoulder symbol for the uniform of a security guard. A simpler approach, perhaps with just a bar linking the letters, is altogether more promising (see previous page, top), and although the last of the examples shown here has taken the idea too far, this is a concept worth further consideration.

A possible alternative might be simple, elegant typography. In an italic face, the V and A will both have strong uprights, giving the word a "squarer" look. There are all kinds of pleasing and attractive ways in which this approach can be developed, and one of them must be a contender for the final short list.

We should also explore the possibilities inherent in the word Vista. It has implications of landscapes or panoramas, which might be worked up, or we could try a more abstract version of this approach.

The two logos, top right, are very satisfying, connotating as they do in an abstract way the earth, sky and sun. This is clearly an area that is worth exploring.

The natural landscape treatment is interesting, and suggests that we might adopt a more sedate approach. The tree is certainly dignified, but we are back to images of autumn, a visual solution we vowed to avoid.

In the Vista example we focused on a particular design route fairly early in the assignment. It is more usual to explore a number of routes, for example conventional typographic solutions and other visual images which could be associated with the name. However, the Vista example shows some of the ways in which a new logo or trademark can be developed from a fairly difficult initial brief.

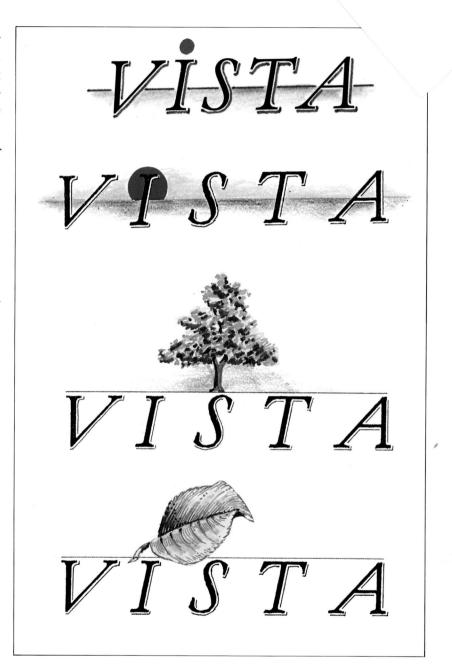

Above Abstract representations of landscape combined with the name, are

strong and appropriate. The red "sun" adds colour. But when solid trees and fallen leaves are added,

the image comes perilously close to some of the stereotyped images of old age.

TELECOMMUNICATIONS COMPANY

We have been commissioned by a giant Scandinavian telecommunications company to design a new logo. Our client is state-owned and is at present largely concerned with the provision of a wide variety of telecommunications services in its home market. It has some export business and sales volumes are, by most standards, considerable; however, the domestic market is considered of primary importance.

The company has a long corporate name which is virtually unpronounceable outside its home market, and its initials happen to be the same as those of a major US automotive manufacturer. The company is in effect, therefore, prevented from using both its corporate name and its initials outside its home market, so when it does conduct business in export markets it usually does so under product trademarks or under the names of subsidiaries or divisions.

However, changes are afoot. There has begun to be talk of privatization and if the company is privatized it seems certain that some of the company's shares will be offered to overseas investors in, for example, Tokyo and New York. The company is also under increasing pressure to compete in export markets. Our client is being forced, therefore, to consider its identity and image, especially outside the domestic market.

In view of the problems it has with its corporate name, an attractive strategy would be to abandon the existing name altogether and adopt a new internationally acceptable name and identity simultaneously. Unfortunately this option is not available, at least at present, mainly because the adoption of a new name would require a special Act of Parliament and this

would take years to arrange and would cause considerable political problems.

The company has therefore to continue to use its existing, somewhat unsatisfactory corporate name, though it is hoped that a name change will be possible within three to five years. Meanwhile it has decided to adopt a new corporate logo which it will use throughout its business to help add unity and coherence to its affairs. If, in the future, a new name is adopted the new logo should by then be well established and will help to ease the change from the current corporate name to the new.

The new logo, therefore, should not be based on the corporate name but should be entirely free-standing. It must also be able to cover a wide range of activities from the provision of special telephones for the handicapped through to the design of exceptionally sophisticated military communications systems using geostationary earth satellites. One of the most common applications of the logo will be as a moulded insert in the handsets of telephones.

The company is well aware that it is a late entrant to world telecommunications markets; it therefore particularly wants a logo which commands attention and which helps it build its own, special identity. It also wishes to avoid a logo based upon the letter T as such logos are already commonly in use by many major telecommunications companies.

The company's expertise is in telecommunications of all sorts including both equipment and services. Central to what it does is the concept of "joining together". The company requires a logo which is appropriate to what it does and which somehow "echoes" its activities.

An obvious starting point for the designer is to explore the concept of a globe, though this has been done so often before it is vital to add a measure of freshness and originality. It is also necessary to go further than merely a stylized map projection as the concept of connecting things together is important.

Designs 1 to 6 show examples of some possible treatments. The circle is certainly a robust shape and meets many of our requirements. Treatments 1, 3, and 5 are particularly attractive – the first is simple and fresh, the second introduces a design element which is communications-related (the thick/thin lines suggest the lines on a TV screen or even the synapse, the means of communication in the human nervous system) and the third preferred solution is simple and should reproduce well, though it may be insufficiently distinctive. The other three examples are either insufficiently original (2); too delicate to work well in all applications (4), or simply rather boring (6).

Next let us explore abstract designs which try to achieve an echo of "connectedness". An imaginative and inventive designer can be remarkably prolific given such a brief - the boxed logos shown overleaf are just some examples. Unfortunately, few of these meet our brief - the triangle containing an optical illusion is, for example, an overused designer trick and does not form the basis of a suitable logo for a major corporation; the triangle composed of three "sticks" does not really suggest connectedness, in fact, rather the reverse; the knot device might be suitable as a logo for a Boy Scout jamboree but does not fit our needs while many of the other designs are uncannily similar to corporate logos already in use - we may not quite be able to identify all of them but we know they exist. Only one of these logo designs really appeals to us - the circular design resembling a

■ Above Exploring the globe concept and trying to give it a new twist. Examples 1, 3, and 5 work best here.

bundle of wires coming together; it is appropriate and attractive though it may be a little too elaborate.

Though we determined to stay away from it, we cannot resist spending a little time looking at logos based on the letter T – examples 7, 8 and 9 are three early attempts though attempt no 8, is reminiscent of the Cross of Lorraine and 9 resembles the logo used by Shiseido on their major Tactics range of men's toiletries. The remaining logo, 7, is simply not very distinguished. We shall stay clear of T designs!

However the "cellular" keypad element in 7

Above and right Logos exploring the cellular keypad idea. Solution number 11, a subtle blending of the cellular and the global approaches is particularly successful, though it may not be quite robust enough.

works well, even if a vaguely similar logo has already been used by at least one telecommunications company – British Telecom, on its pre-paid telephone cards.

It may, however, be worthwhile exploring this approach further. Examples 10 to 15 are variations on this theme.

Let's return to the concept of "connectedness" and work on this a bit further. Examples 16 to 19 demonstrate some variations on this theme, though 19 reminds us more of woven fabric than of telecommunications. Numbers 17 and 18 both work particularly well.

So already we have six or so tentative designs which, at first sight, appear capable of doing the job in hand.

As you will see, when you undertake assignments to develop more abstract logos where the constraints are quite broad it is necessary to range widely and explore a variety of options. Not all will work well – indeed many will not work at all – yet you will find design solutions emerging which are attractive, which meet your design objectives and which you can present with confidence to your client. Remember, however, that only a small number will really work well, so you need to be highly selective. Remember too that even the design which is finally selected will have been substantially modified during the subsequent process of design refinements.

Above Examining the theme of "connectedness" 17 and 18 are effective but 19 might be better suited to a textile company.

The practicalities

No special tools or techniques are peculiar to the design of trademarks. The basic skills, tools and techniques of design apply whether you are involved in costume design or logo design. A designer working in the area of logos and trademarks should be fully conversant with, and trained in, the "basics" of design, but he does not need, generally, to have additional technical skills unique to this area.

Nevertheless, as we have seen, he or she should pay particular attention to matching the design solution to the short- and medium-term practicalities of the client's business: in other words, the designer must aim to be something of a business strategist. The objective should not be merely to create "design for design's sake", but rather to create a design that does a job and does it well.

There are, therefore, what might be called "attitudinal" differences between designers working in the trademark and logo area and those working in other design areas. In addition, there are certain practical aspects of design in which such a designer should be particularly well versed and competent.

LAYOUT

A bad layout is one that does not work, it is one that does not lead the eye naturally and sensibly from one point to another in the desired order. It is not coherent, balanced and appropriate to the job in hand.

For example, most book jackets feature the title as the main element, with the author's name less prominent. Some popular writers, however, such as John Le Carré or Harold Robbins, are featured in screaming capitals while the title of the book seems something of an afterthought. The reason for this is, of course, that the name of the author and not the title of the book is the major "draw" to consumers. It is the same with movie posters. If the movie has a star such as Paul Newman or Dustin Hoffman, the film's title will play second fiddle. A low-budget movie, on the other hand, with little-known actors will require a poster that focuses on the title and subject of the movie, not on the actors.

To do its job properly a letterhead must feature clearly the company's logo, address details, telephone, fax and telex numbers and so on and still leave enough space for a letter. If the logo is too big and you can't fit a letter on the same page, that's a bad layout. If the telephone numbers are too small to read, that's a bad layout.

Similarly, a brochure should present to the reader a clear invitation to open it and absorb the contents. A magazine, book or record cover should provoke interest and attention. Equally, you should follow certain obvious rules. For example, if you are designing a record cover, remember that it is likely to be stood upright in a rack so that the prospective purchaser flicking through a pile of records will see only the top part of each cover. You should, therefore, place

■ The layout of the letterhead should be planned so that the company's identity is established clearly without it taking up too much of the available space – remember you must leave room for the message. Also the relevant details such as the address, telephone number and fax number should be set out clearly. Letterheads above and far left use space creatively while still doing the job. Left A striking design for The Graphic Workshop.

Above A logo which uses a creative typeface based upon the individual letters themselves. Over the years novel typefaces have been developed from digitalized letters and telephone handsets, even from nude ladies in a variety of poses.

the information relevant to the purchasing decision – the artist's name and the album title, for example – on the top part of the cover, while other information – the song titles, name of the orchestra and so on – can go elsewhere.

A menu should remind you what restaurant you're in, what each meal consists of, what comes with it and how much it costs. If it contains much or all of this information but you have to struggle to sort it all out there is a basic flaw in the design and layout.

But beyond asking yourself the simple question "does it work?" there are no firm rules to layout. Anything goes – almost. Layout is as much about turning the accepted ways of doing things on their heads as anything else. For instance, the word "letterhead" implies that the logo goes at the top of the page, but why not put it at the *bottom* if it works best that way? In most instances it will not work well at the bottom, the design will appear unbalanced, but in a minority of cases it will look terrific.

Most often the design itself and its function will, by their own built-in requirements, determine whether a layout works or not. Just keep asking yourself if it works. Be critical. If you adopt an innovative or unusual layout, be suspicious of it until you are sure you have a better solution. It may be attractive and unusual to write your client's name and address sideways on his notepaper, but it may drive him and his customers crazy. It may be interesting to put the artist's name at the bottom of a record sleeve, but it may damage sales. On the other hand, if you are designing a logo and layout for a book about Japan, it may be entirely appropriate to place the book details on the back cover and not the front in order to mimic Japanese practice; the book will not, of course, be read from back to front, but the reader will have no doubt of its subject and content. The reader will, in a sense, gain an "echo" of Japan from your innovative cover design, and this will seize his attention and help to focus it on the subject of the book.

TYPOGRAPHY

At the time of the invention of printing in Europe in the Middle Ages, most typesetting was in Latin, the language of the educated classes. Early type foundries took as their models the type shapes of the Roman calligraphers and of the carved inscriptions of Roman monuments and tombs. These classical typefaces are, with minor modifications, still widely used today.

In the search for more legible and compact type, early alphabets were cut and recut, and later generations of typographers used these early models for more and more alphabets. The result is that today's designers have a wonderfully rich and varied, even bewildering, array of typefaces from which to choose.

Today, of course, filmsetting and computer setting processes have taken over from the old metal-setting process, but it is useful to have a knowledge of the old metal-setting techniques, if only because many of the terms still used to define and describe type are derived from metal-setting techniques – "face", "point sizes", "kerning", "typesetting", and so on.

Skill in typography is the single most important skill that a designer of trademarks and logos must possess to do his job. You do not have to be a fine draughtsman, but you must be able to reproduce convincing typography by drawing, tracing or even by the use of dry-transfer lettering. You should also develop skills in the recognition and choice of typefaces. Buy books, look at magazines, learn to identify type, compare

type, trace type, draw type. Steep yourself in, and become sensitive to, the beauty of typography. Nobody has ever learnt too much about type and nobody ever learnt all there is to know. It is a curious paradox that there are literally thousands of typefaces in existence, some quite beautiful and others absolutely bizarre, yet the greater your knowledge of type, the narrower your focus becomes as you close in on what you consider most appropriate and most appealing in a particular application.

SPECIFYING COLOUR

People have been theorizing and arguing about colour for centuries, but ultimately the choice of colour and of colour combinations is a personal one. A useful book is the *Designer's Guide to Colour* which shows both the basic, clinical aspects of colour and the more personal emotional aspects. It also presents a wide number of colour combinations so that you can judge these for yourself and make your own selection.

The designer, however, needs to be able not

■ Left Logos can be manipulated to produce a range of interesting effects and such manipulation is now very much easier for the designer due to the advent of computer graphics.

■ Above The PANTONE*

Matching System is a proprietary system which allows the designer to specify with precision the colours required. The PANTONE* system is now used internationally and all good printers will be familiar with it.

■ Right The London Black and White Company wittily uses a four colour logo. Clearly these colours need to be specified with precision.

only to select colour and colour combinations but also to ensure that the colour he or she wants is the colour that eventually appears on the letterhead or brochure when it comes back from the printer.

There is no doubt that although some designers have a greater "deftness of touch" with colour than others, skill with colour can be much enhanced with practice and experience. As a designer you will work continually with colour, and you should take a test for colour blindness early in your career and perhaps every 5 to 10 years thereafter. Some people (a small minority) have excellent colour skills and sensitivity across the board, others have no colour sensitivity at all, but most of us lie somewhere between the two extremes. It helps to know where you stand. Having established your basic colour skills, these, like all other skills, can be enhanced. If in doubt on matters of colour selection and combination, seek advice and outside opinions; even if colour is not your great strength, this should not prevent you from being a great designer of trademarks and logos.

We can specify colour in two main ways, both of which are internationally understood. The first system is the PANTONE ** MATCHING SYSTEM. Using about 15 basic colours plus white and black, PANTONE ** has created a numbered colour guide that will allow you to communicate to a printer just about any colour you want simply by quoting the relevant colour reference number. This system can be used for spot colours, backgrounds, indeed for anywhere you want a flat special colour. A PANTONE ** guide can be obtained from any good art equipment shop. A particular feature of the system is that the same

^{*}Pantone, Inc.'s check-standard trademark for color reproduction and color reproduction materials.

numbers apply over a broad range of products: paper, graduated tints printed on paper, gloss papers, matt films, gloss films and markers. The standards are high and colour matches are close.

The second major system, based upon the four-colour process, the basic method used to reproduce full-colour continuous-tone copy – illustrations, prints and transparencies and so on – relies on the four basic printing colours: process cyan (blue), process magenta, process yellow and black. By using different percentages of the basic colours, it is possible to create almost any colour. For instance, 20 per cent cyan with 20 per cent magenta will give a delicate pastel violet; 70 per cent yellow with 70 per cent magenta will give a vivid orange. These charts may be a little harder to obtain but your printer should be able to obtain them for you.

ILLUSTRATION

Most designers are not skilled illustrators, although they can often prepare credible rough sketches of what they are looking for. Much illustration work is therefore sub-contracted to specialist illustrators. There are hundreds of such illustrators working in a vast array of media: airbrush, pencil, gouache, watercolour, acrylic, oil, tempera, scraperboard, woodcut, linocut and so on. In addition, highly sophisticated computer graphics techniques are now available, and even colour photocopies can be a useful source for the designer. It follows therefore that you should be familiar with all these techniques; you should also know exactly what you are looking for or else you are likely to be disappointed. Remember too that most illustrators are comfortable in only one or two techniques, so you must seek out the right illustrator for the job.

To avoid confusion and disappointment, make

Bovis

International construction and civil engineering

■ Above Mervyn Franklyn's letterhead, designed by Linda Gray in 1975, is amusing and striking; also, as designers are notoriously spare with words, he can afford to leave little "white space". Left The humming bird chosen by Bovis as their logo might appear odd for a building company, a fact compounded by the finely drawn design and four-colour presentation. But the contradictory nature of the image has undoubtedly contributed to its success.

■ This page The published "instant archives" of illustrations are copyright-free and provide the designer with a mass of highquality illustrations of all types.

sure that the illustrator fully understands your requirements for the finished product – its style, size and colours. Agree also on a delivery date and discuss the price *before* commissioning the work. Consider too whether the cost is included in your own fee or will be charged as an "extra" to the client. Indeed, consider whether the job justifies expensive illustrations at all.

In addition to specialist illustrators there is an important and useful source of inexpensive copyright-free illustrations: borders, banners and objects. This is the published "archives" of illustrations, which have been specially selected for the designer. Letraset and other producers of dry-transfer sheets include a useful range of illustrative material in their catalogues. Then there is the extensive Dover Publications series of "archive art", some 300 books in all, covering everything from food to furniture. Instant Archive Art and the Encyclopaedia of Illustrations are other useful sources. A little research will reveal dozens more. Although published illustrations of this sort will hardly be suitable for every job, many designers have been most grateful that such sources exist.

To be a designer of trademarks and logos you do not need to be a great illustrator. You do, however, need to understand illustration and illustration techniques and to be able to specify clearly and nominate with confidence the illustration you want – either from a specialist illustrator or from existing available archive material.

PRINTING AND SPECIAL PRINTING PROCESSES
The best way to get a good result when ordering
print is to be precise and meticulous in your
instructions to the printer. Designers often forget
that the printer has not spent weeks with them
looking over their shoulders while the details of

the job are agonized over. They forget too that the printer will be handling dozens of jobs, not just theirs. So spell everything out: the paper, the weight, the colours, the finishing processes. Be aware that the printer is not a mind-reader, and you will get fewer shocks when the finished job is delivered.

A comfortable familiarity with print production techniques is essential to the designer of trademarks and logos, and as far as basic printing and production techniques are concerned *Production for the Graphic Designer* by James Craig is invaluable in explaining and illustrating production techniques. You will find the subject fascinating and one on which modern technology is having a particular impact.

In addition, there are several special printing processes that it is useful to know about. The first (and most expensive) is *die-stamping*, also known as *engraving*, by which the paper is stamped in relief between matched male and female dies while ink is injected. As well as colours, metallic golds and silvers are possible. *Blind embossing* is the same process without the ink and can give a fine, subtle effect. Both techniques can greatly enhance the graphic impact of a trademark or logo.

A similiar process is *hot foil blocking*. Literally dozens of effects are possible, including marble, pearl, simple matt colours, metallics and coloured metallics. In this process a metallic or pigment leaf is stamped on to a surface usually in letter form or as a logo.

A somewhat cheaper process is known as *thermography* by which you can achieve a relief effect by dusting the still wet ink with a fine powder that is then heated.

Finally, there are various finishing processes all of which can enhance a trademark or logo

design. First, there is normal *varnishing*, which can be done either on the printing press with rollers, or off the press with a spray gun or coater. Varnishing can protect the design and give it depth and clarity. It is available normally in matt or gloss. Then there is *spot varnishing*, whereby you can apply the varnish exactly where it is also wanted. This technique can be used to highlight trademarks, logos, photos or illustrations. It also is normally available in matt and gloss finishes and by alternating between matte and gloss some interesting effects can be achieved. Spot varnishes are applied with a rubber blanket, which has to be cut by hand, so over-complicated effects are not possible.

You can obtain a particularly deep, shiny finish by specifying *ultraviolet varnish*, a special varnish cured by exposure to ultraviolet light. You can also obtain spot effects through this technique. *Lamination* is a technique that can be used to obtain a deep, shiny finish, but spot effects are not possible here as the lamination consists of a thin layer of plastic covering the entire printed surface.

From just these few examples you will see that

■ Top An extremely ingenious change of address card using cut out type. The letters M V and E have been cut out and appear (centre) inside the card, upside down, as part of the corporate name – Waverly. Right A blindembossed logo on hammered finish paper, Zeta Matt Post. The effect is terrific but expensive.

a wide range of print and special production techniques is available. You will find it useful to familiarize yourself with the various techniques and to liaise closely with your printer and seek his advice when you have a particular, non-standard requirement. Be aware too that no printer will be able to offer all the possible alternatives and that certain of the special printing processes are relatively expensive and should be approved in advance by your client. You will normally find that even if your client is not prepared to shop at the top end of the print market you should be able to obtain a satisfactory result by a less expensive production method.

PAPER AND OTHER MATERIALS

There are literally thousands of different papers on the market – printing papers and boards, letterhead paper, vellums, drawing papers, bonds, rag paper, mattes and glosses. Arm yourself with samples from all the major paper manufacturers and consider carefully the choice of paper for each job.

For instance, if you are selecting a paper for a letterhead, you have to consider not only whether the paper looks good but whether it will actually work in an office environment. If you are using a coloured paper, can you correct typing errors? Does your client use a feeder to make multiple copies of documents? Will the paper feed through a copier? If your client uses laser printers, will they accept your paper? Can you fax it? Also, if you have a special process in mind for printing the letterhead – for example thermography, embossing or engraving – check with a printer that the paper is suitable for that process.

If you choose a paper for a letterhead, make sure too that you can get matching envelopes. Some paper suppliers will supply standard matching envelopes but not those with self-adhesive flaps or address windows. Check too if the envelopes come only in made-up form. If they do, you might not be able to print where you like on the envelope. Find out if you can get a matching board for business cards; this may not be a critical factor but, given a choice between two papers you like equally well, it may tip the balance in favour of one.

Similar considerations apply to other materials. If you design a trademark or logo for use on packaging, make sure that it will reproduce well. Waxed cartons, for example, will play havoc with all but the most robust designs. Plastic containers pose similar problems and, if you are in doubt, it is always sensible to talk to the technical department of the packaging supplier or to one of their representatives to establish what is possible and what is not. Indeed, you will often find that the packaging suppliers are delighted by your interest as these specialists are inclined to suspect that designers live in an ivory tower and venture out into the real world only infrequently.

MECHANICALS

Once you have agreed on the final design, but before you can instruct your printer to start work you need to translate your finished sketches into finished (or "mechanical") artwork, sometimes also known as camera-ready artwork. This is an important part of the entire process as substandard finished artwork will seriously affect your design.

Most printers have a mechanical artwork facility and there will be hundreds of artwork studios eager for your work. Not all, however, will be of equal competence. Recommendation and thial and error are the only ways to sort them out, and

■ Above Plastic cartons used for many food stuffs take printing well, allowing for a sophisticated design. Waxed cartons, such as those used for milk, however, do not print well. They allow for little subtlety of design and may destroy all but the most robust logos.

once you have found a good studio stick with it. The longer you work with one studio the better you will understand each other's methods and requirements; and, like every other aspect of the design process, the best way to achieve good results is to know exactly what you want and be able to communicate your wishes precisely.

THE PRESENTATION

Designers (who are, after all, essentially in the business of "presenting" material) frequently make a complete hash of presenting their design solutions to their clients. All too often designers simply lay before their client a *smorgasbord* of potential design solutions and ask the client to take his pick. The background to the project is not reviewed and neither are the designer's own insights or observations, his own findings, the thought processes he has followed or his preferences and recommendations.

Remember that you have been called in as a consultant, not as a draughtsman. When you present your design you should:

- Demonstrate an understanding of the problem.
- Justify your solution or solutions.
- Make recommendations.

It is well worthwhile putting together a structured presentation *before* going to your client. This does not need to be elaborate, but it demonstrates care and thoughtfulness.

Start your presentation by a review of the job in hand – what it is, the background, the market, consumer attitudes, your client's specific requirements, budgetary and other constraints, scope of international coverage and so on. Prepare a summary of these points in advance on a flip-chart, overhead slides or projector slides, and go through all the points with your client fairly

quickly – 10 or 15 minutes should suffice. A simple summary of this kind will fix everyone's attention fairly and squarely on the task in hand (your client may not have given the design job a moment's thought since he briefed you a month ago), and it will also ensure that you are all on the same wavelength.

Then summarize *your* findings and conclusions. For example, that consumers appear bored with competitors' designs, or that your client's earlier proposal to adapt the logo of a company he has recently acquired may be counterproductive, or that the potential use of the logo on special point-of-sale racking in supermarkets imposes constraints and opportunities not previously considered. Again, you can best summarize and emphasize your findings and conclusions by the use of slides or flip-charts.

Only now do you start showing your designs. Keep them of sight until this point. Don't pin them up or scatter them on the table – your client will take no notice of a word you say if you let your designs out of the bag too early!

Now take your client through the design process – briefly. Show some preliminary ideas and sketches, albeit in a rough form. Present them one by one – either the sketches themselves or slides made of them. If possible, pin up each idea as you present it so that your client has a complete visual reference to which he can return. Discuss each one, tell him what you like about it and what you don't like.

Finally, present in detail your preferred solution or solutions. The solution should, of course, flow from the initial brief and from your own investigations; and, preferably, certain of the themes that you have started to explore in the initial design work should be present in the preferred solution.

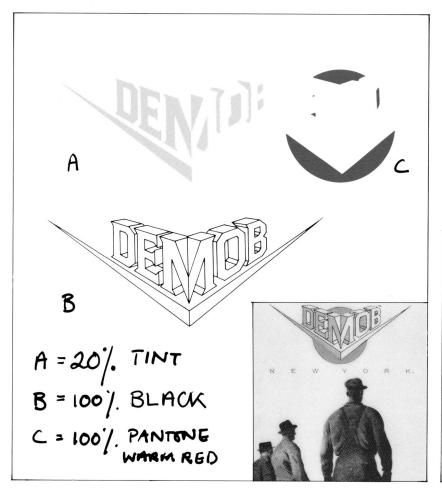

Be prepared to justify the final design solution. If, however, you present more than one solution, by all means have a view as to the one which is your favourite.

You do not need to present highly finished artwork at this initial presentation stage. Rather, develop your designs to the stage where your client has a clear idea of how they would work in practice. For trademarks and logos to be used on packaging some simple labels stuck on containers may be useful. If the new logo is to be used mainly on letterheads, some hand-drawn letter-

heads, envelopes and business cards showing the logo as it would be used would be far better than simply the logo on its own.

Be prepared for the fact that your client is almost certain to change any proposals you make. He will prefer blue to red, or a different typeface, or the logo at the top rather than the bottom, or that element of that design together with this element of this design. Don't be too "precious" about your work. Don't be upset by his suggestions or antagonized because he is fooling around with "your design" – after all, he is

Above Modern printing presses are very expensive and need to be-operated at high utilization levels if they are to pay their way. Printers will therefore be handling at any one time dozens, even hundreds, of different jobs. To achieve the effect you want, therefore, you must be clear and precise in your instructions to your printer as even a small mistake or misunderstanding can be very expensive.

CLIENT	JOB DESCRIPTION	JOB NUMBER	
DATE RECEIVED	DATE REQUIRED BY CLIENT	DATE COMPLETED	
VISUAL	DATE REQUIRED	DATE COMPLETED	
ARTWORK	DATE REQUIRED	DATE COMPLETE	D
PRINT DETAILS		CREATIVE COSTS	
EXTENT			
QUANTITY		VISUALS HOU	RS
COLOURS			
		ARTWORK HOU	RS
STOCK			
DELIVERY DATE			
		TOTAL HOURS	
EXTERNAL COSTS		Retail cost	Invoice cost
GRAPHIC MATERIALS			
TYPESETTING PRINT			
PHOTOGRAPHY			
FREELANCE			
PMT's			
TRAVEL		-	
TELEPHONE			
MISCELLANEOUS			
		TOTAL	

■ **Above** It pays to estimate your costs carefully in advance and, as a job proceeds, to keep track of the costs you are incurring and how these compare with your estimates.

the client! On the other hand, if you disagree with him, tell him so. You are a consultant, and fewer consultants have been fired for speaking out than for not speaking out.

Finally, don't succumb to the temptation of presenting not-so-good ideas so as to flesh out a presentation. Make sure that you like *all* the ideas, or the client is bound to choose the one you don't and you will be stuck with developing an idea you don't believe in.

PRICING

Design is a very competitive business, not least because it provides a working environment that is creative, varied, absorbing and satisfying. It therefore attracts a lot of talented people. Thus competition for new work is often fierce and design is frequently a buyer's market.

Nevertheless, if you want to do a good job for your client you should be realistic in preparing budgets. Work out not only your direct costs – typographers, illustrators, rubdowns, acetates, special papers and so on – but also your own time, including that spent with your client, the time you spend planning and organizing the job and the time you spend actually handling the job.

In general, clients prefer you to prepare a clear and realistic budget before you start a project and then complete the job within the budget, rather than prepare a low estimate and then come back to them for more money to cover expenses you did not foresee.

Remember too that few of us shop at the bottom end of the market and buy the cheapest available product – if we did, companies like BMW, Jaguar, Porsche and Mercedes would be out of business. You do not necessarily do yourself any favours by being the cheapest in the market place. Quality is what really counts, and reliability runs it a close second.

YOUR OWN REFERENCE SOURCES

Build up your own library of reference books. There are hundreds of books on typography and graphic design, and they can be immensely useful in the search for inspiration and in problem solving. There is a list of selected reading matter at the back of this book. Just leaf through a book while you are thinking about your problem. Things will leap out at you – a line of type, an

approach that might work, an ingenious layout. This is not, of course, meant to encourage outright plagiarism; after all, you can scarcely expect to find in any book the exact solution to your design problem but while browsing you may well get some fresh ideas.

You should aim to build up a library covering typography, modern design trends, the history of design and design materials and techniques. You should also maintain your own catalogues, samples of papers, colour indexes and so on. In addition, books of available illustrations, books containing drawings of animals and birds, books of prints by Old Masters and the French Impressionists, atlases, histories of discovery – all can be invaluable when you are seeking inspiration or, sometimes, by showing you that a cherished notion is nonsensical!

PERSEVERANCE

Every designer knows the terror of facing a blank sheet of white paper, while hanging over him like a black cloud is the knowledge that he has to come up with a devastatingly good idea for a trademark or logo.

Also every designer has his own way of dealing with this problem. One designer cannot start to design anything unless he has an A3 marker pad and five sharp HB pencils; another cannot begin without his favourite propelling pencil and A4 tracing paper. Some even prefer the backs of envelopes. We all seek to create our own mood and setting for creativity and recreate it every time we are called on to come up with something original.

Most designers will agree, however, on one basic principle: quantity greatly helps quality! Ten good ideas are better than one, for several reasons. First, the more good ideas you start with, the higher the standard of the ideas that survive your own internal selection process. More will survive to go to the client and, importantly, he will feel he is getting his money's worth.

Second, what you perceive as a great solution might simply not appeal to the client. Or he may like it but it reminds his secretary of a snake, a spider or a skull. Most logos will be vetted by a committee – one person will like this, another will prefer that. It is rare that a solution is universally admired.

During the early stages of the design process, jot your ideas down as simply as you can to get the idea across. Don't get too bogged down in the detail and the execution - put the idea down on paper so you can return to it when you want and then go on to the next idea. When you have dozens of rough ideas and sketches you can pick out the ideas that are worth taking further. A solution you might have thought clever at the time and spent a lot of time developing, might not seem so brilliant when you look at all of the ideas together. Work on the basis that there is always a better idea waiting to be explored - the longer you can bring yourself to think about a project the better, although you will at some point inevitably reach the stage where your brain throws in the towel.

FINAL THOUGHTS

Try to avoid the banal – banal and familiar design solutions are all too easy to achieve; strive to inject a little extra something into your work. A little style, a little humour, a little originality go a long way. As a rule fresh, original ideas take a lot more work than boring, hackneyed ideas, but there can be no doubt that the results will be worth the extra effort.

Case studies: actual

In this chapter, we will show you some actual trademark and logo design exercises undertaken by leading design firms. The clients involved range widely in size and the design problems they present. What is apparent in each example, however, is that the process of designing trademarks and logos is not a "Eureka!" one. Rather, the designer has to be analytical and systematic: he or she must work closely with the client; a wide range of design options need to be explored; and the preferred solution requires meticulous detailed refinement.

BRITISH AIRPORTS AUTHORITY

The British Government from 1985 onwards followed a policy of returning a number of state-owned enterprises to private control. This was carried out by floating the companies on the stock market and organizations, such as British Airways, Rolls Royce, British Gas and British Telecom were all privatized in this way.

Another company which was privatized was the British Airports Authority (B.A.A.). B.A.A. runs eight of Britain's airports including Heathrow, Gatwick and the main Scottish Airports. Formerly, it reported to the Department of Trade and Industry, but, in 1987, it was floated on the market.

This new status brought about two important changes for B.A.A. First, it became responsible for its performance directly to its shareholders in

the same way as any public company. Second, its brief was relaxed to include other commercial activities not previously permitted to it as a statutory authority.

B.A.A. is a substantial foreign currency earner for Britain, both through the charges it makes to airlines for use of the airports and their facilities and through the duty-free and tax-free concessions which it manages. B.A.A. is the world's most successful airport group and Heathrow claims to be the world's largest airport.

So, when it was decided to privatize the organization, B.A.A. recognized that it had a new investor audience and that a new and more flexible identity was required to reach this audience – one that would be as suitable for an annual report and accounts as for a directional sign or for an information desk.

■ Above and right The old British Airports Authority identity and logo style is institutional and a little forbidding – and not applied in an entirely consistent way.

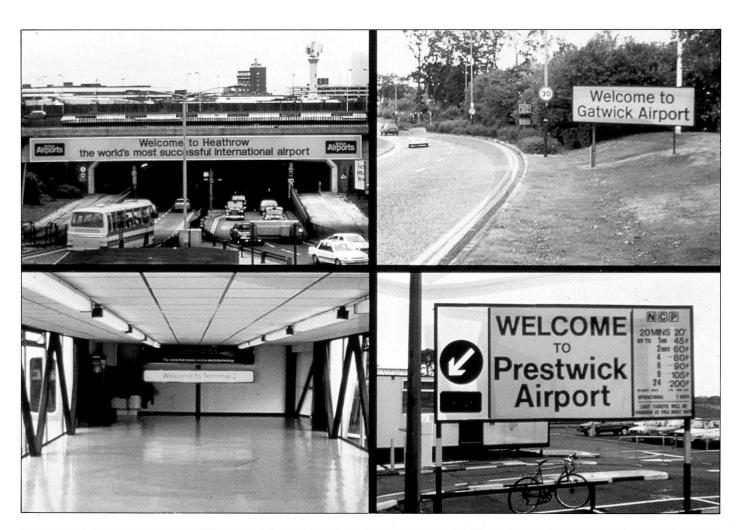

BAA

*Heathrow

■ Left At the initial design stage a wide variety of designs and logos were explored. Here the designer experiments with typographic and purely graphic solutions. With hindsight, was the best option chosen? **Above** One of the early designs, later dropped, though elements of it do appear in the final solution.

HEATHROW **3 A A** BA·AM B:A:A

A, Y. 🖁 🔼

■ You can see the designer's mind working as he tries out different ideas – experimenting with arrows which echo the take

off path of an aircraft (far left), also seeing how the logo looks applied to the side of a truck. **Above** Exploring the concept of the

vapour trail. **Below** Type and image married together, a not altogether comfortable union.

An early thumbnail sketch.

The airplane instantly dates the logo.

The stylized arrow loses the concept of an aircraft.

This treatment recalls a number of existing airline logos.

When the designer tries to make it more distinctive it becomes a collar and tie.

B'A'A

The company name does not rescue this design.

A vapor trail or a flashlight from an upstairs window?

The dynamic sweep is stylish but the stylized aeroplane loses balance in this treatment.

The dark shape recalls an aeroplane...

...But does not work when divorced from the square.

A rather flat variation on a theme.

Overstylized, the concept is largely lost

B·A·A

■ Aeroplane and vapour trail – the designer minutely explores the possibilities. **Bottom left** We are now getting closer to the finished solution – a single vapour trail, a dynamic, stylized aeroplane resting on the corporate name. Note how the periods between the initials echo the shape of the aeroplane.

■ The new B.A.A. logo and identity is used on airport equipment, trucks, uniforms, stationery – even on baggage carts and china.

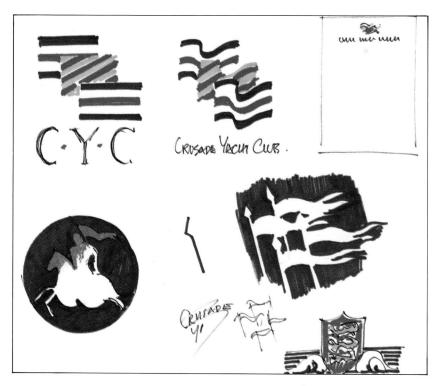

CRUSADE YACHT CLUB

The Crusade Yacht Club was established for the purpose of encouraging yacht racing. Initially the Club opened in Fremantle, Western Australia, for the 1987 America's Cup but its principal purpose is to provide a Club and meeting place for those yachtsmen and women who are interested in competitive yacht racing at the highest level. The Club will therefore continue to be interested not only in future America's Cups, but also in other premier events and will be based in Cowes, Isle of Wight, the major yachting centre off Britain's South Coast.

The brief to Tayburn Design was to design a logo for the club that would strike a balance between the traditionally conservative nature of clubs of this type and the dynamism of the club's high-profile, high-achieving members.

■ A whole variety of solutions were explored including those based on the image of a crusader and of heraldic symbols. The marine signalling flags for the

letters CYC formed the preferred design solution which are colourful, lively and appropriate.

COCA-COLA

In 1986, Coca-Cola briefed Landor Associates to undertake a complete review of the Coca-Cola brand identity and packaging design system. Their requirement was for an appropriate upgrading of the trademark to suit changing conditions but without diluting the existing equity in the brand.

The first stage was to study the three basic elements – the dynamic curve, the trademarks Coca-Cola and Coke and the proprietary colours red and white. Any global solution had to retain the investment in the brand, allow the clear differentiation of products, give Coke a strong "family" identity and provide an integrated system that would work for all foreseeable line extensions and applications.

Landor proposed therefore that the new global identity should be made to look more contemporary and impactful, should unify the dual identities and should create consistency across all packages and applications.

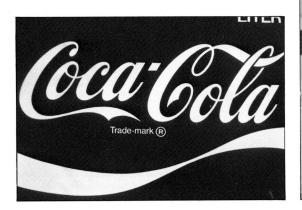

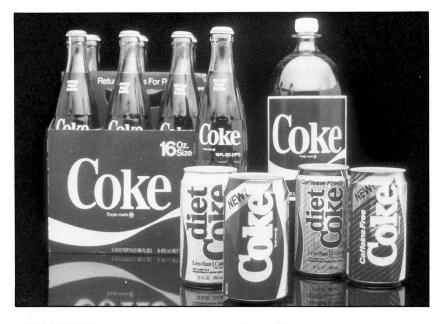

■ **Above** The old logo as it appeared on a range of packaging applications.

■ Far left The old logo. Left The old logo was carefully analyzed to identify the key design elements and hundreds of different design directions were explored.

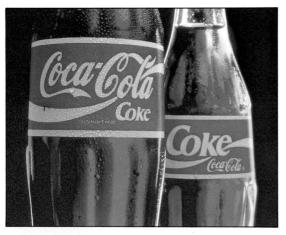

■ Left, top and centre The Coca-Cola script was made bolder, opened up and slight detailed changes were made to accommodate the curve – for example, the 'I' was redrawn. The Coke logo became bolder and italicized so as to harmonize with the flowing Coca-Cola script.

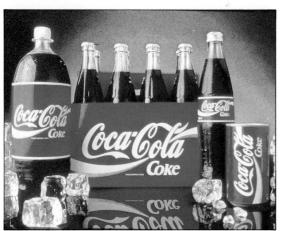

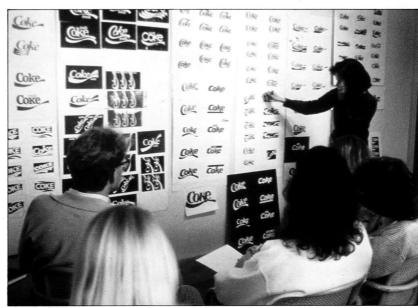

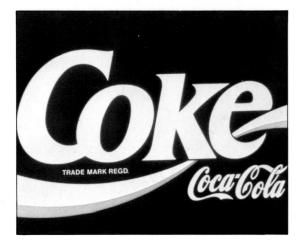

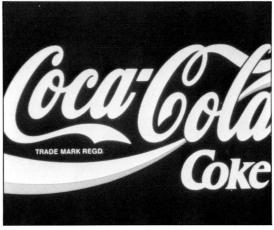

■ Left, far left and above Two new logos were developed, one featuring Coca-Cola prominently with Coke tucked under the main logo and one focusing on Coke with Coca-Cola in the lower position. Both logos shared the same dynamic curve redesigned to run through the main letterforms.

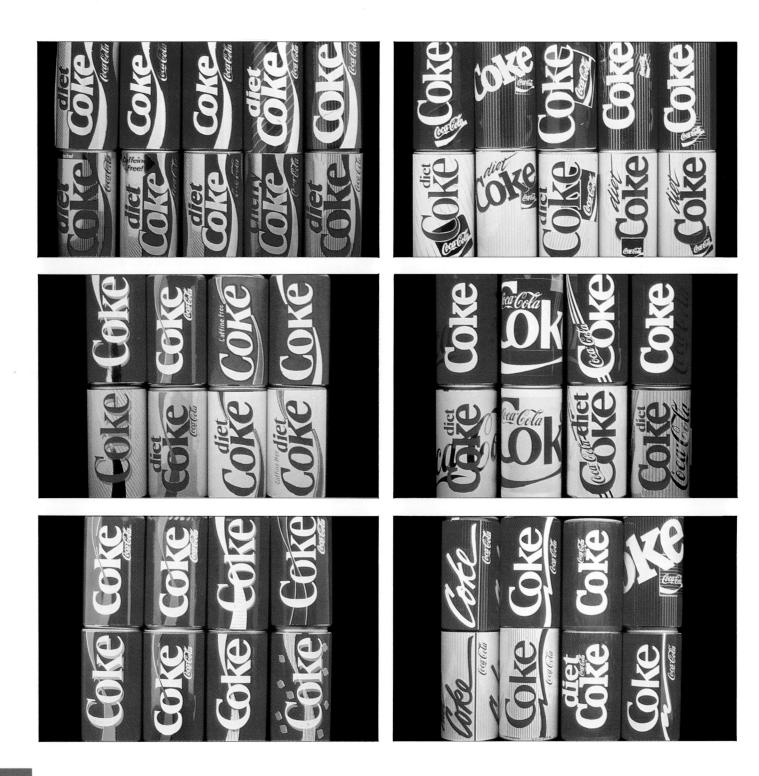

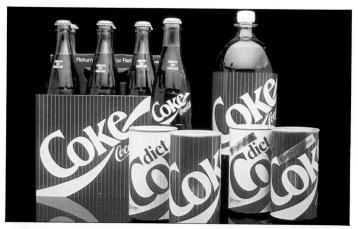

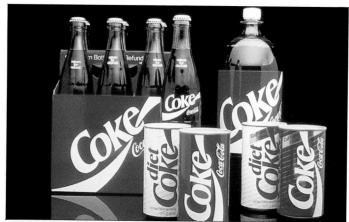

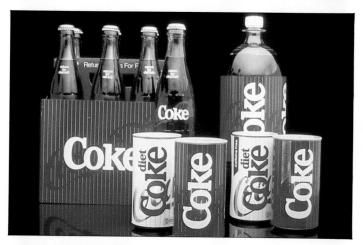

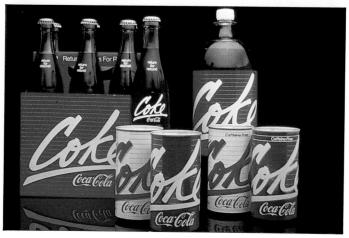

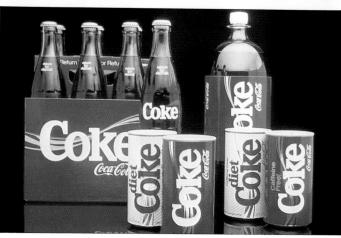

Every possible variant of the familiar Coca-Cola and Coke labels was explored though efforts were made to preserve intact the valuable and powerful recognition factors built up over the previous hundred years. Somewhat extreme variants such as the one immediately above were tried but dropped as they wasted much of the existing equity in the brand. All shortlisted design solutions, 11 in all, were tried on prototype packs and a range of other applications.

DUCKHAM'S QXR

Alexander Duckham & Company commissioned Siebert/Head to design a revolutionary oil container, a new logo and a label design for its new premium motor oil – QXR.

The new oil is a technical breakthrough, far superior in quality to competition, and commanding a premium price. Motor oil is a very "macho" market area. The typical target consumer for QXR is the man who loves his car, enjoys technology and engineering and is prepared to spend extra on a premium oil as long as he believes it to be genuinely superior.

Imagery is the key and, since advertising support will be limited, pack design is crucial to the success of the new brand. The image and function of the pack should match the product's high performance and present QXR as distinct from the competition – futuristic and expertly engineered. Strong graphic design, which would complement the container shape in creating a high-tech image, was the other aspect of the brief.

Left Duckhams motor oil is a well-respected brand in the UK and elsewhere. Motor oil is usually something of a commodity product and a large number of brands compete for the consumer's attention. Far left Cans of Duckhams standard hypergrade oil are seen here screaming for attention along side their competitors. QXR, their new premium motor oil, needed an image which could thrive in this environment. Below QXR has been positioned as futuristic, expertly engineered, appealing to the enthusiastic motorist. There were various stages in the design process; first some ideas for the logo.

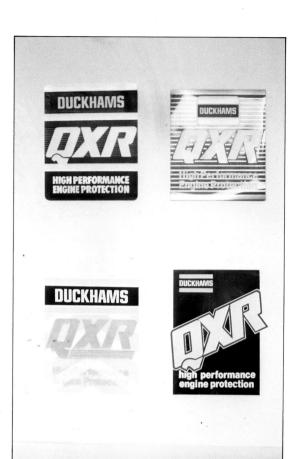

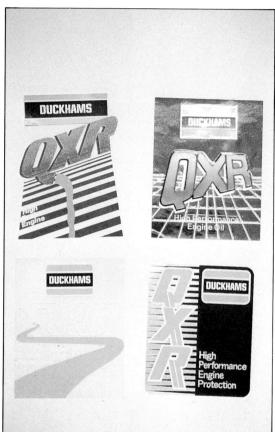

■ **Above** More ideas that will appeal to the motorist who loves his car and is prepared to pay for a high quality product.

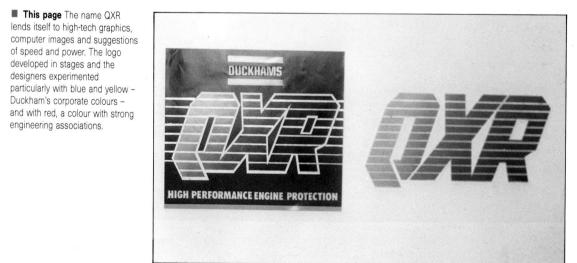

■ From the outset the logo, the label and the unique container shape were perceived as an integrated, three-dimensional trademark. **Above** The traditional tinplate oil-can is awkward and messy to use; it rusts, is easily damaged and has an outdated image.

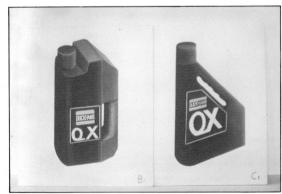

■ High-density polyethylene was selected as the new pack material. **Above right** First the colour is chosen. **Right** Some flat developmental designs working towards the new container shape.

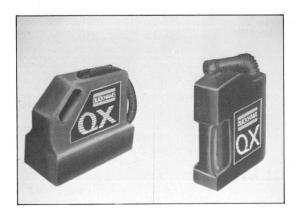

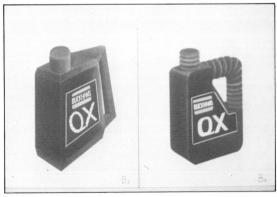

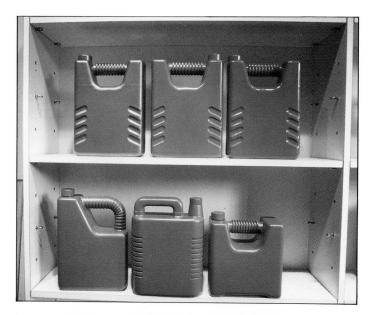

- Left The final logo fits well with the chosen container shape to achieve the revolutionary image desired. The distinctive "can" has a premium metallic blue finish, a ribbed handle for easy handling and gives an "engineered" appearance. Other features include a double-threaded nondrip spout and a feature to allow air to escape and prevent "glugging". Above In practical terms, the new 3-D logo can also be applied to promotional and point-of-sale material.
- Above left When the dummies were made, squat shapes proved stable but did not pour well and a side handle proved most practical. Some were too expensive to produce.

GLADE

The Glade Range of air "fresheners" is an important consumer product for Johnson Wax. Fitch & Company was commissioned to produce a new design formula. The first objective was to create a new brand identity which was more modern and relevant to the consumer. The second objective was to introduce a coherent design to span and unify the range.

The dilemma for the designers was that much of the existing imagery for air "fresheners" centred around flowers and floral presentations. A range of entirely new design concepts was considered and preliminary ideas were presented to Johnson Wax in concept form.

- Above The old Glade range. ■ Above right A competitive review was undertaken to establish the retail environment.
- Right The design team considered a variety of new abstract ideas and discussed these with the marketing team.

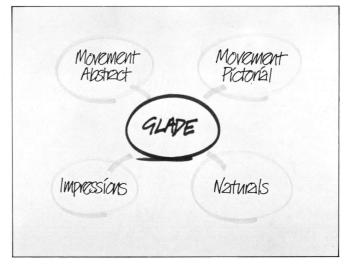

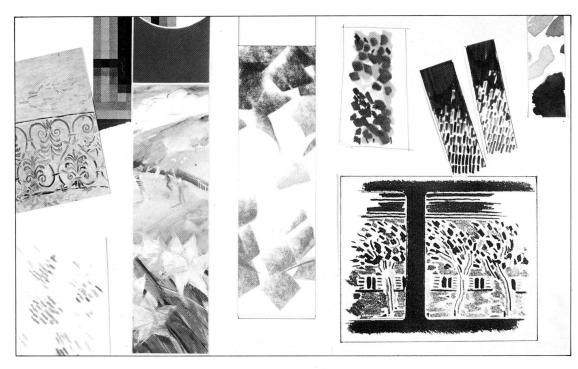

■ This page A number of mood boards were then developed to add images, colour and atmosphere to the preferred concepts. The daffodil concept is relatively traditional yet the treatment is fresh and original. The composite kite/butterfly treatment invokes outdoor qualities yet is animated and flowing.

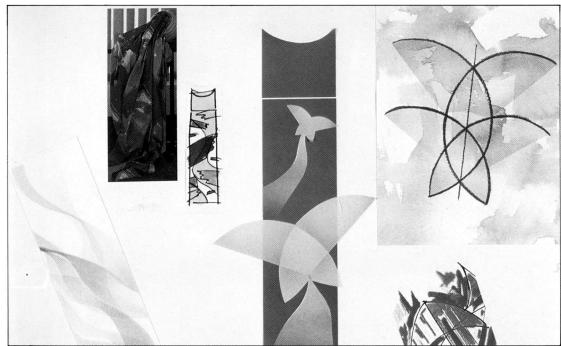

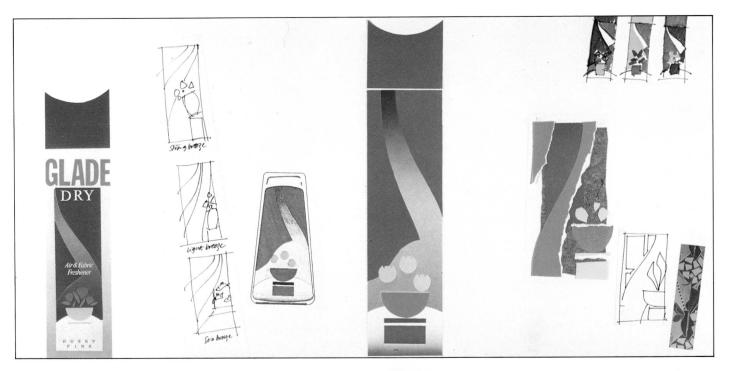

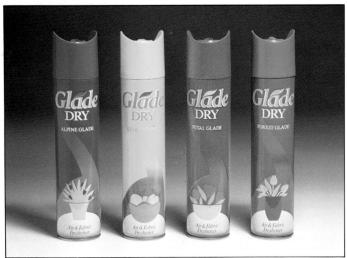

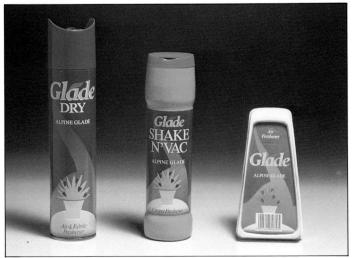

■ Top right Eventually the preferred "mood" focused around the billowing curtain formula which uses the theme of fresh air blowing through an open window thus capturing the essential

benefit and effectiveness of the product. **Top left** More detailed designs were evolved for the individual packaging.

■ Above left Each of the aerosol fragrances has its own distinctive identity yet the range is entirely cohesive. Above right The design solution was extended to cover

the slow release and carpet freshener products.

■ Right The gateway with columns and a crest design is fairly traditional though the style is fresh and contemporary. Right The seagull flying over London idea symbolizes freedom. Both possible solutions were eventually rejected though both scored far higher in research than the traditional LCCI logo and crest (below right). Below left The "talking heads" design symbolizes the networking function of the Chamber and was the selected design.

LONDON CHAMBER OF COMMERCE

The London Chamber of Commerce's market research showed that too many people viewed it as "a staid, fuddy-duddy institution."

Coley Porter Bell worked with the Chamber to define a new strategy. The main strength of the Chamber was their resource of business-to-business contacts, a network invaluable for improving and expanding all areas of industry. The key design objective was to communicate clearly these benefits offered to members, with an obvious relevance to the spectrum of business prevalent in today's London community.

The radical new look has, not surprisingly, caused much comment – any big change is bound to be controversial. Roger Fisher, Head of Marketing and Membership, thinks this is definitely a good thing. "Clearly we are not now in the 1880s. People are contacting us to say they like the new corporate identity and want to join the Chamber. We can now also appeal to the new generation of young business people and in doing so we are achieving one of our major objectives."

HAYWARDS PICKLES

Brooke Bond Oxo, part of Unilever, came to Smith & Milton because their Haywards Pickles range, a brand leader, had a logo style and packaging which was considered out of date and inappropriate for today's highly competitive market. The range was to undergo a relaunch and Smith & Milton were asked to come up with potential new positionings for the brand. These consisted not only of a new logo, but also a complete packaging face-lift.

Care was taken to ensure that these would work as company logos in their own right – on promotional or advertising material, as well as on the packaging itself. The selected design trades on a graphic heritage which includes pub signs and circus posters.

- Above The original Haywards Pickle style a logo and labels which had become dated and unattractive.
- Left A 1930s logo style, which is bold, colourful and original, is derived from circus posters and reflects the tradition and nostalgia of Haywards.

■ Top The logo style is based here upon the comic strip. Centre A black background with a bold logo produced a dramatic and unusual effect. Below The light, natural "fork" logo is healthy, homely and reassuring.

■ 1 The circus poster logo style combined well with graphics derived from the traditional British "naughty" seaside postcard. 2 The comic strip lettering led directly to label designs using a comic strip approach. 3 The logo based on a

black background was lightened through the use of a colourful border and amusing graphics. 4 The "fork" design worked well when simple graphics were added.

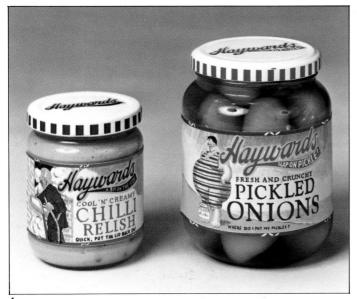

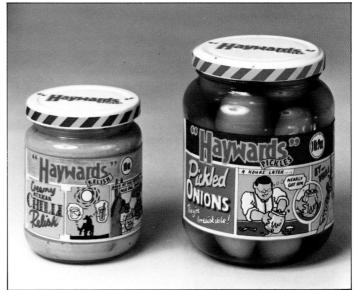

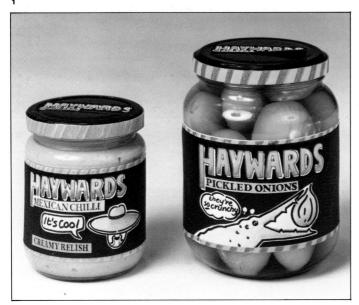

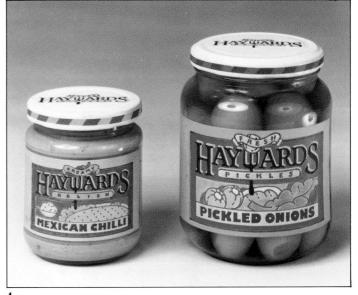

3

■ **Left** The final logo rough uses elements drawn from the initial prototype logos.

■ Above In the course of development, the lighthearted illustrations were dispensed with so as to enhance the brand's credibility. The colours of the logo were modified for maximum shelf impact.

■ Right The finished pack features an eye-stopping logo. Bold bright colours and mixed typestyles for a contemporary look which still retains a traditional feel.

REPSOL

When Spain entered the European Community, it became clear that the Spanish national oil company (I.N.H.) would face the onslaught of open competition both in its own market and elsewhere. It had to be able to compete against the giant international oil companies.

The decision was taken to adopt a new group name, Repsol, formerly the name used for a brand of lubricant in Spain, and Wolff Olins was appointed to develop a new identity for the group. The new identity would be used on tankers, oil rigs, retail stores and service stations. It had to be capable of competing with the "majors" yet it had to be synonymous with the new industrial fast-moving Spain.

■ Right The final version of the Repsol logo is informal and approachable yet highly distinctive and flexible. It is also fresh and quite different from the identities of other major oil companies. The new look evokes the work of Miro and has distinct "echoes" of Spain.

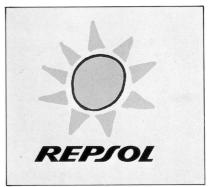

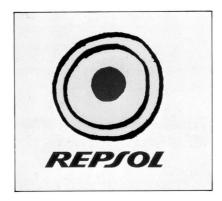

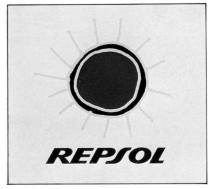

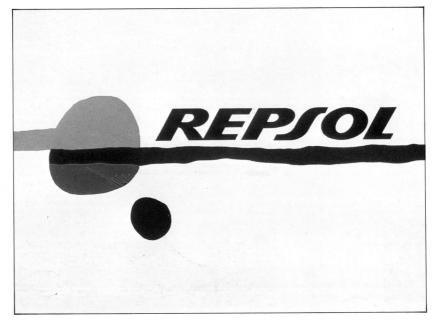

■ Above Images associated with the sun were particularly attractive to Repsol, the major Spanish oil company, as the sun is universal and powerful, visually distinctive, yet has direct associations with Spain.

SILVER SCREEN

Silver Screen Management is a film financing company which offers investment opportunities to both large and small investors. Pentagram New York were asked to design a logo for Silver Screen that would suggest some of the romance associated with movies while connoting financial stability.

Prior to deciding on a typographical treatment, images associated with movie-making and Hollywood were explored but rejected as Silver Screen's story is more than movie-making and these images would be too limiting.

■ Left The Silver Screen typeface is Brace Condensed. The shadow effect suggests that the words are lit against the background of a screen.

■ Below Paul Davis produced a new painting for the "21" Club to serve as a corporate symbol. For the logo (bottom left) the typeface Torino was selected.

THE "21" CLUB

The "21" Club in New York City asked Pentagram New York to design a new identity. The existing "21" logo was modified, and a new painting was commissioned.

Remington's collection of wild West paintings, an original symbol of the "21" Club, was rejected as inappropriate. The iron gate symbol was also dropped as it was felt to be too daunting and masculine and the Club's new posture was to encourage a younger clientele, including women.

A pplying and maintaining the design

THE TRADEMARK OR LOGO is often the core of a corporate or product identity. Inevitably, the new trademark or logo will be used much more widely than just on notepaper or on packaging. The new logo for Torq Computer Systems will, for example, be used initially mainly on stationery and brochures, but over time, it will appear in advertising, on instruction manuals, on stands at trade fairs, and perhaps even on a financial prospectus.

Large corporations, concerned that their "design projection" has become out of step with their corporate personality and corporate ambitions, not infrequently commission design companies specializing in corporate identity to overhaul their corporate image. Corporate identity specialists often describe themselves as "part management consultants, part designers". They undertake a full review of the corporation, its plans, its problems, the attitudes of customers

■ Kuwait Petroleum has adopted the name Q8 and a new corporate identity for all its retail activities across Europe. It is used in many countries, on scores of products and in hundreds of different applications. Clearly the logo needs to be applied in a planned, controlled fashion or there could be design anarchy. Below and right The logo applied to a business card and a petrol station.

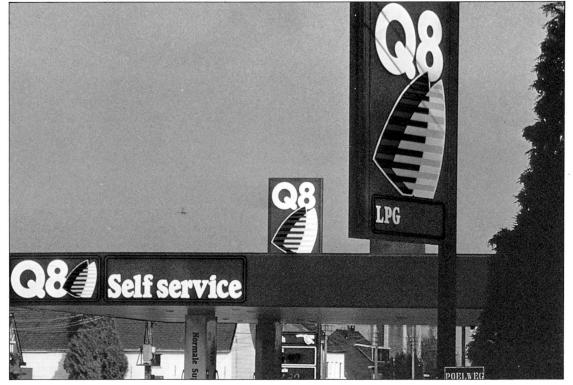

THE HENLEY COLLEGE LIBRARY

and consumers, attitudes of the financial community and of employees, the progress of the corporation versus that of its competitors and so on. They then propose design solutions to overcome any deficiencies in the design area.

Major corporate identity programmes of this type are frequently triggered by mergers or by changes of management, although in fast-moving, fashion-conscious industries such as airlines and fashion retailing it is becoming increasingly common for a review of the corporate identity to be undertaken periodically, perhaps every five to seven years, without any specific external trigger.

Major corporate identity programmes can be massively expensive operations. When British Airways undertook such an exercise in the mid1980s it cost several tens of millions of pounds – all the aircraft were repainted, interiors were completely changed, uniforms were redesigned, check-in counters were re-modelled, and even glasses, napkins and swizzle sticks were changed. In this instance the designers handled the entire programme from initial concept development through to detailed implementation.

The dilemma for the designer of trademarks and logos is that he is not normally responsible for detailed implementation and that the new design is likely to be used far more widely than originally envisaged. For example, the computer software house will decide to retail microcomputers and will open a chain of stores; the new logo will come to be used, therefore, on shop fronts. Alternatively, the trademark

■ Below left The corporate identity manual provides clear rules as to the usage of the Q8 identity. These rules define colours, spatial relationships, use on letterheads and printed material – in fact, every conceivable application. Below The Q8 logo applied to a range of stationery.

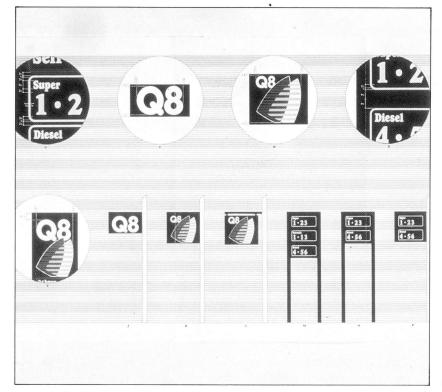

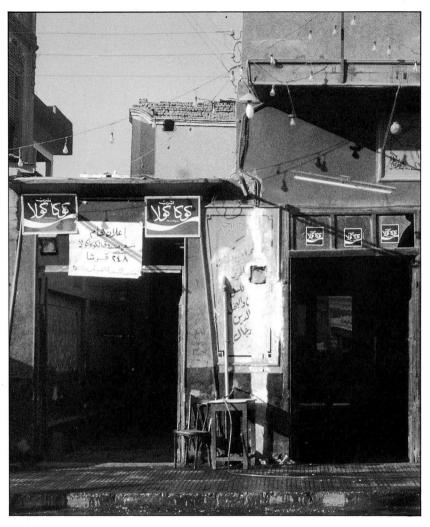

■ Above The Coca-Cola logo is used in virtually every country of the world and revisions of the logo, with a distinctive Coca-Cola look to them, have been developed for all major non-Roman scripts – for example, Hebrew, Chinese, Arabic and Katakana.

developed for a new candy bar will be extended to cover a range of confectionery products, including Easter eggs, Christmas selection boxes, special value packs, and so on.

It is important therefore that the designer of trademarks and logos:

■ Think ahead as to the likely (or even the possible) future use of the new trademark or logo.

■ Assist his client by providing guidelines for future use so that the new design does not become corrupted.

Businesses are dynamic and nothing ever stands still. If you propose a design solution that is well adapted to today's business but that is inflexible and inextensible, you can be sure that your client will want to go into a new business tomorrow and that your fine logo design will be shoe-horned into an application for which it was never intended.

You can also be quite certain that your client will not call on you to oversee the detailed implementation of the design, at least beyond the first few weeks. He will give a copy of your design to a printer, and the printer, will do with it what he will: "We didn't like those fancy bits so we left them off" or "That colour looked a bit wishywashy so we went for a stronger one". So too with the signwriter; he will cheerfully "adapt" your design, as will the president of the French subsidiary, the agent in Tokyo and the client's recruitment consultancy.

Now we are not suggesting that you become too "precious" about your design. You have done your job, you have been paid for it, and it is now your client's problem. He has his business to run and will do so as he sees fit.

It is clear, however, that if you come up with an inflexible or over-fussy design, or one that is so contemporary and of-the-moment that it looks dated even two or three years later, or if you have failed to anticipate likely future client requirements, your design is quite certain to be corrupted.

It will also get corrupted if you do not communicate properly the basic guidelines for usage – for example, that the logo can be placed above the company name or to the left of it but never

below it or to the right of it, or that the logo should never be reversed out or turned around or embedded in some other graphic treatment. You should also be exact in your colour specification.

ANTICIPATING FUTURE NEEDS

Of course, you as the designer can hardly be expected to foresee in detail what your client will be doing in five years' time, when your client himself does not know what he will be doing in five months' time. However, when you are developing the design brief, you can probe a little: "Are you likely to open overseas offices?" "What are your plans for exterior signage?" "What trade fairs will you exhibit at?"

Equally importantly, at each stage in the design process you will be faced with the need to focus on one or a few alternatives and to discard others. It is here that you can build in flexibility and concentrate on designs that, if they are required to do so, will work well across a range of applications and not be inflexible and particularized to one or a handful of applications.

It will be apparent to you, for example, that certain intricate logos will be too detailed for use in, say, newspaper recruitment advertisements; that "locking" the corporate name into the logo can cause difficulties as it may be desirable, for example on continuation stationery, to use the logo on its own without repeating the name; that blowing up the first letter of the corporate name to a large size (a sort of modern version of an illuminated manuscript) with the rest of the name much smaller, can look great on notepaper but may not work on the side of a truck – the B of Black may be visible from the other end of the street while the –lack part is indecipherable.

Many of the acquired skills of the designer of trademarks and logos are in this area of selecting solutions that are flexible and that work over a range of applications and an extended period of time. There are no fixed rules in this area (and, as we discussed earlier, the most inspired design is often the one that bends the apparent rules or applies them in a fresh and original way). Nonetheless, think carefully before you breach any of these broad guidelines:

- Avoid logos that are too intricate or fussy.
- If you have designed a logo that has colour in it ensure that the logo still works well in black and white; ensure too that the colours are closely specified.
- Avoid design solutions that are too voguish or of-the-moment. Try to achieve a timeless quality.
- Avoid unusual, obscure or non-standard typefaces.
- Avoid logos that float and have no obvious reference points to indicate where they should be located on, for example, a letterhead.
- Avoid an overcomplicated design strategy or solution, even if it appears intellectually sound for example, Division X can use red on a black background, Division Y blue on a pink background and Division Z can use their house green plus their old bulldog symbol to remind the old-timers that until we took them over in 1959... etc., etc.
- Avoid designs that are so particularized to today's business they would not work well if the client decided to expand.

MAINTAINING THE DESIGN

Any design is liable to be corrupted, but the better design solutions are somehow more robust and coherent, they command more respect, and they do not as readily lend themselves to tinkering.

■ Above and right Preparing and maintaining a comprehensive and precise design manual is expensive and time consuming. However, for major companies with far-flung operations, especially those such as service and distribution centres – which use the identity but are not under the company's direct control – it is an essential discipline if the identity is not to be corrupted.

Most major corporations produce extremely detailed design manuals that specify closely how the corporation's trademarks and logos are to be used, their precise colours, unauthorized applications, the juxtaposition of the corporate name with the divisional name (if any) and with the product trademarks, the precise typeface and colours, the black and white versions of the logos and trademarks, the use on vehicles of all sorts, on directional signs and so on.

Large corporations may well use hundreds of different advertising agencies in dozens of countries; they may use thousands of different printers and have tens of thousands of distributors. Unless they lay down clear and unequivocal instructions as to the use of the corporation's trademarks and logos, the result would be chaos.

In 99 per cent of cases, however, your client will exercise personal control of implementation or will argue that his size or turnover does not justify the preparation of an elaborate manual. Even in these cases you should try to set down a concise description of the trademark or logo, how you envisage it being used, the precise colours, any important spatial relationships that should be followed and usages to avoid.

■ **Above** The distinctive Shell logo has evolved considerably over the last century. In the latest version, the name and logo are separated, a tribute in part to the familiarity of the logo.

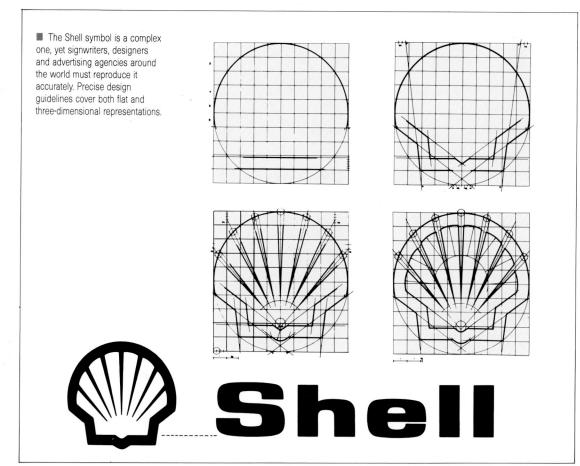

This is not to say that you should prepare a mini-design manual. Rather, because the concept behind the design and its application, factors that are entirely clear to you, but may be much less clear to your client and possibly totally unclear to your client's staff and colleagues, you should help to provide a few fixed points by committing to paper what you think is self-evident. Even though people and circumstances will change, the core of the design will maintain its integrity.

UP-DATING THE DESIGN

Those companies whose trademarks and logos are applied coherently and consistently benefit because the personality they project to the world is one of coherence and consistency – customers, suppliers and others perceive the company as "having its act together", as knowing what it is doing, of being well organized and of being efficient. Conversely, a muddled, illogical, fragmented projection of a company's trademarks and logos will damage the company's image.

It is clear, however, that a company needs to project more than just a coherent image and message; it must project an appropriate image and message. For this reason advertising needs to be up-dated from time to time, as does packaging, the products themselves, the methods of production and so on.

This is also true of logos and trademarks. They need to be reviewed from time to time and updated; otherwise they will become hopelessly old-fashioned.

The dilemma for companies is that it requires a great deal of time and, normally, a great deal of investment for logos and trademarks to acquire a familiarity and potency in the marketplace. We have already noted that advertisements and jingles often start to make an impact with con-

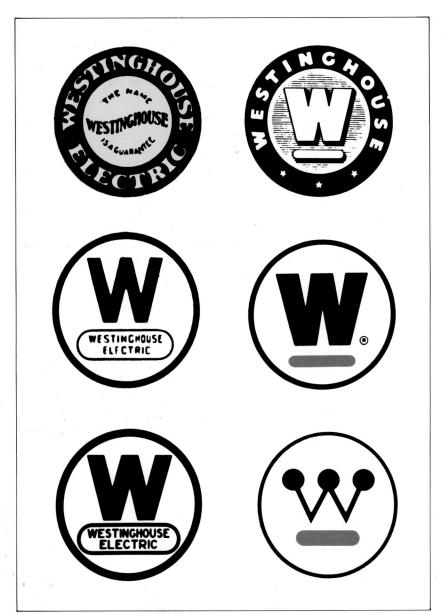

■ Above The Westinghouse Electric logo has evolved considerably this century though the rounded shape has remained common throughout. The

distinctive W was adopted at the time of the first major revamp of the logo and has been used ever since, most recently in a highly distinctive, even eccentric, form.

Below The first Benz logo, the name in a gearwheel, dates from the nineteenth century, yet logos of this sort are still used by many industrial concerns in Communist countries. The Mercedes star, which has been said to resemble the spokes of a steering wheel, is

now the predominant feature of

the Mercedes-Benz logo.

sumers just when the advertiser and the advertising agency are beginning to get heartily sick of them. Of course, the consumer is exposed to them on far fewer occasions than the company or the agency, and the consumer is also less interested in them.

So it takes a lot of time and effort to establish trademarks and logos in the public consciousness. It is, therefore, important to be careful, even reluctant, when changing them. Certainly change for change's sake, because you have become bored with the old logo or because you, a new person on the scene, want to implant your own personality, is to be avoided.

But trademarks and logos do become outmoded and old-fashioned, and they do need to be overhauled and kept up-to-date. Normally the overhaul should consist of an up-dating of the design while the key visual elements are retained. Ideally, there should be a strong continuity in the design, and the loyalties and values inherent in the old trademark and logo should be carried over to the new design without a hitch.

The symbols and logos of Shell, Coca-Cola, Kodak, Volkswagen, IBM, Mercedes, Prudential Insurance, Anaconda Industries, Hoechst, Sony and scores of other major corporations have been up-dated innumerable times without

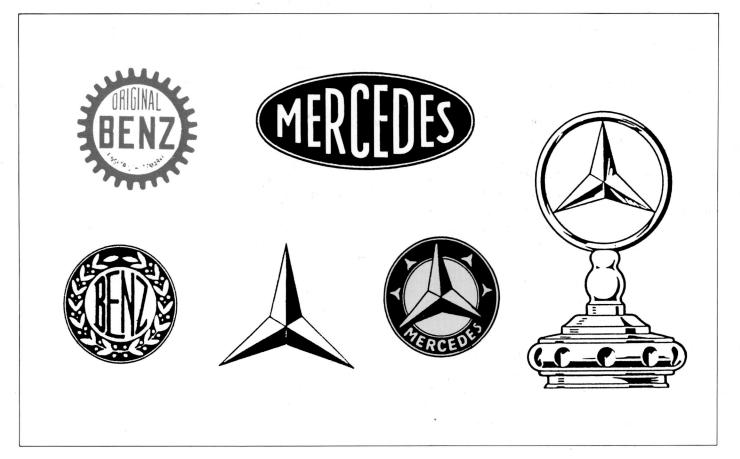

■ Right The John Deere logo is a simple visual pun. It has changed remarkably little over the years, though the tail started to creep up fairly early on.

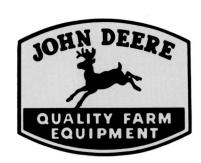

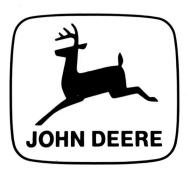

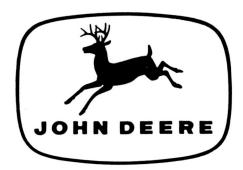

■ Above Through the use of the TM symbol, Coca-Cola is careful to give notice that its trademarks are the property of the company and, by implication, will be defended against unauthorized use.

in any way diluting the equity already invested in these logos. Major corporations safeguard their images jealously and work hard to ensure, when an up-date is required, that the change is made as smoothly as possible. Smaller corporations should in most cases adopt the same policy.

MAINTAINING RIGHTS IN A NAME

Just as care needs to be taken to ensure that a trademark or logo design is not corrupted or otherwise damaged, so too is it important to ensure that any legal rights in a name are not diluted through misuse. If the following rules are followed there should be no danger of that happening:

- Always distinguish the trademark from any surrounding text, for example by capitalizing it, by the use of boldface, etc.
- Always follow the trademark with the dictionary name for example, "the world's leading manufacturer of Vaseline petroleum jelly", not "the world's leading manufacturer of Vaseline".
- Always use trademarks as adjectives, never as nouns say, "Work it out on your Apple

- computer", not "Work it out on Apple".
- Never use a trademark as a verb do not talk about Xeroxing or Hoovering, even with capitals.
- Take care never to use the trademark in the plural for example, "Two Disprins are all you need". Say instead, "Two Disprin tablets are all you need".
- Do not use a proliferation of different graphics treatments for the same name. Once you have a graphic design, stick to it.
- Make sure you let the world know which names are trademarks. You can do this by using the R symbol, the TM symbol or the SM symbol. Internationally, TM can be used for unregistered trademarks though it is often used for registered marks, too. In the US, SM is coming to be used to distinguish service marks. In all countries R is widely used for registered trademarks of all types.

These rules are necessary because it is not unlikely that at some stage your client will need to defend his trademarks, and the way in which he has used them is likely to be of critical importance in any legal action. If, for example, he has not clearly identified his trademarks as being his property, the other side may claim ignorance – "Yes, we examined the product but didn't realize that name was a trademark – it doesn't say so anywhere". Or, if the trademark is misused, the defendant might claim that your client had actively encouraged others to misuse the name through, for example, treating it as a verb.

So, while we are not suggesting that you get paranoic about it, make sure you are not too heavy-handed in the treatment of any corporate or product names and don't get upset if the lawyers want to change a few detailed points of your design.

D eveloping new brand names

IN MANY INSTANCES the main means of differentiating one brand or company from another is the name. After all, if you are introducing a new mass-market traditional beer you cannot do a great deal about the colour, taste or formulation or even about the basics of packaging or price. The brand name and the product image are the main means of differentiating one brand from another. To an extent, the same is true of companies. Although you may strive to offer a better service, more competitive prices and more highly trained and courteous staff, in practice, in most sectors the differences between company X, company Y and a score of others are slight. But one potent way of differentiating your company is through the name. Cobweb is a much more striking and memorable name for a corporation supplying integrated communications networks than is CGN Communications. Sunburst is a more interesting and dramatic name for a breakfast cereal than Morning Brek.

So how do you develop effective brand or corporate names – names that not only will help to position the new product or service but that are attractive, memorable and protectable and will stand the test of time?

Like design, the development of names involves a range of different skills – creative, linguistic, legal and strategic. Historically, names (i.e., "word trademarks" and corporate names) have been developed by the "eureka" process – the company is named after its founder, who

names the company's products while he is in his bath. Although this process is still commonly used, it has its drawbacks, not least because the world's corporate name and trademark registers are becoming more and more crowded. Each year appoximately 750,000 new trademarks are registered around the world, and already there are three million registered trademarks in Europe, one million each in the USA and Japan and about 20 million worldwide. Clearly the chances of the "eureka" name being legally available are becoming more and more remote.

SELECTING THE NAME

Name development necessarily involves a process of careful refinement – a great deal of ore has to be fed into the hopper in order to produce a small amount of pure gold: the attractive, strong, protectable name. The best way to start, therefore, is to create a long list of names, which is then pared down to manageable proportions. In order to develop potential names, brainstorming sessions can be very useful (they should last for at least two hours, and the best material will come towards the end of the session), supplemented by research in dictionaries, reference books and so on. At this stage you should aim to create a working list of up to 1,000 potential names. To reduce this list, eliminate those words that at first sight have inherent pronunciation defects or problems of legibility, memorability or meaning. You should also eliminate all those words

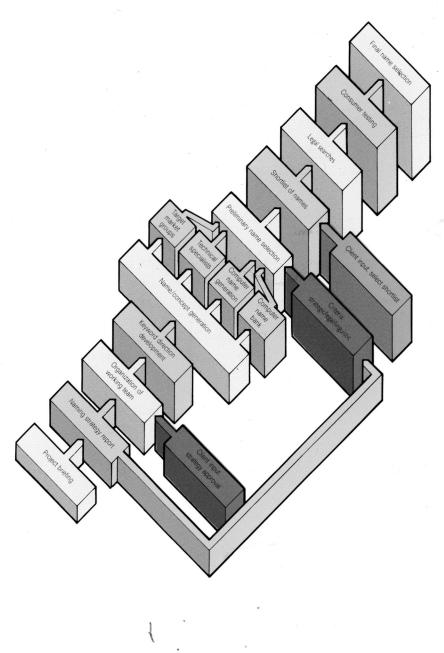

that cannot be registered as trademarks, that are too close to existing competitive marks or that fail to meet other criteria – for example, length.

In this way, the initial list of names can be reduced to between 50 and 100 candidate names. These should be discussed in detail with your client and a preferred short list of some 20 or 30 names drawn up. Although none of these words would have been checked yet for registrability, they should all appear capable of doing the job.

This shortlist should be thoroughly checked in all the languages covered by the potential market, and then tested with consumers and ranked according to preference. Frequently, a simple five-point scale technique is adequate at this stage for name ranking purposes. Consumers can simply be asked to rank the names in relation to a product description on a "like" versus "dislike" basis. On other occasions it may be necessary to test the names in rather more depth - strength versus weakness, masculinity versus femininity, expensive versus inexpensive, for example. Mapping techniques can also be used to relate the shortlisted names to existing competitive brand names. In any case, it is sensible to have the shortlisted names arranged into a broad rank order before starting the legal screening.

Of the 20 to 30 names tested on consumers, perhaps 15 or 20 will survive to legal screening. This may seem an extravagant number of names, but in such overcrowded areas as pharmaceuticals, food, drinks, cosmetics and telecommuni-

[■] The "Eureka" approach to naming brands is inevitably being superseded by more systematic methods, particularly as today's crowded trademark registry means that relying solely on inspiration is rarely likely to result in a legally available name. Left A chart showing the procedures.

Completely free standing

Associative

Completely descriptive

■ **Above** The brand name spectrum showing types of brand name and where they appear on the scale.

cations the chances of a free international name (or even a free national name) emerging at the end of the process are unacceptably low if one does not start with a list of this size. Even with 15 to 20 carefully chosen names, it would be unusual to find more than two or three free names at the end of the legal screening process.

LEGAL SEARCHING

The next step is full legal searching. (The law of trademarks is discussed briefly in Chapter 11.) A good starting point is to ask your trademark lawyer or trademark agent to carry out national and international searches on all the shortlisted names using computer searching facilities. This service is quick and reasonably thorough. He can then undertake full detailed searches of the apparently available names plus searches, where appropriate, of unregistered names.

Such searches and negotiations are expensive and time consuming. It is not uncommon, for example, for a single name to encounter many apparent objections. These must be checked; often the owners must be contacted; and sometimes commercial agreements are necessary. In one recent case a company had to agree to its Dutch subsidiary buying flour from a French company, in return for which the French company gave the company rights to one of its trade-

marks. In other cases it may be necessary to conduct detailed confidential investigations to check independently if a trademark is being used and if so on what products. Sometimes it may even be necessary to threaten legal action to have a trademark cancelled so as to secure it in a particular country.

You will see that developing new names that fit the market positioning of the new product or service and that are acceptable, distinctive and legally available is by no means easy, especially when one is looking for an international name. However, the name is often of central importance to the company or product's personality and is so difficult to change at a later date that the effort can be well worthwhile.

THE BRAND NAME SPECTRUM

Companies often tend to seek descriptive names. It is somehow felt that such names will help sales, and scant attention may be paid to the longer term implications. But why does the name need to contain an overt message? After all, the advertising, the graphics and the packaging all convey messages to consumers. So why also use the brand name to describe your product? To hazard the long-term success of the brand by adopting an unprotectable descriptive name is clearly absurd.

A name like Kodak has no element of descriptiveness whatsoever; it is a pure invention. So too is Exxon. They are both collections of letters that are short, memorable, strong both graphically and visually and yet have no "core" of meaning that is instantly intelligible. Sunsilk is an attractive name for a shampoo. It has connotations of softness and associations with the great outdoors. It is by no means a pure invention but instead draws its strength from images and associations relevant to us all. Bitter Lemon is purely descriptive of a lemon-based mixer drink. It has little invention and as a result is virtually unprotectable.

These brand names span the brand name spectrum from totally free-standing names to completely descriptive names. All brand names fall somewhere along this spectrum. Schweppes, a name with delightful in-built onomatopoeia, conveys images of effervescence. Formica is mainly an invented name but has a core meaning. VISA is a name with associations of travel and crossing boundaries, and Sweet 'n' Low is a name with a high descriptive content.

In general, the more descriptive a name the more it communicates immediately to the consumer. Unfortunately such names tend to be less distinctive and less protectable. By contrast, the more free-standing a name, the less it immediately conveys to the consumer and the more the brand owner needs to invest in it to confer upon it the qualities of excellence and superiority he requires. Between these two extremes lie "associative names", those that are distinctive and protectable and yet communicate some appropriate message or messages to the consumer, perhaps subconsciously.

This middle route, the associative route, can and does result in powerful, attractive and protectable brand names. Kodak might have fared as well had Mr Eastman adopted a name such as Vista, but it would hardly have been in as powerful a market position today if he called his company Super-Pic or Easi-Foto.

IS IT WORTH IT?

The name is central to a product's or a company's personality. It is seldom changed and is an essential prerequisite of international marketing. It can become an asset of enormous value. Obviously it pays to get the name right at the outset, to select one that is legally available in all the countries of interest and to remove all third-party obstacles at relatively low cost before launch and not at very high cost after launch.

Curiously, however, such a systematic approach is often ignored. Organizations select names with profound marketing and legal defects. They spend fortunes in litigation trying to resolve inherent legal defects. Not infrequently, they even have to withdraw products from the market.

On other occasions they choose names that are misleading or instantly forgettable, or that severely hamper the development of a powerful and differentiated product or corporate personality.

In an age in which companies spend tens or even hundreds of millions of dollars or pounds a year advertising and promoting a single product or service; when the clutter and noise in most sectors increases constantly; when those magical market share points can be worth hundreds of millions of dollars or pounds, the importance and power of the brand name or corporate name continues to grow. Within the name resides all that investment. After all it is the clear, identifiable aspect of the product that the consumer uses in selection and purchase.

Legal aspects of trademarks and logos

WE HAVE TALKED A NUMBER OF TIMES throughout this book about the need for names to be available and protectable, about the fact that brands can be valuable assets and about the dangers of imitation and counterfeiting. Trademarks and logos clearly therefore have some legal content to them – but what?

It is not our intention to try to turn designers into lawyers, but all designers need to have some broad idea of how the law applies to their area of expertise, if only so that they know when to call for help.

Anyone who sits down with a blank sheet of paper – be he or she a writer, a designer, a musician, an inventor or a painter – is about to create "intellectual property." In other words, the very act of using one's brain, skills and imagination – i.e., one's intellect – to create a drawing, a design, a piece of music or a sentence means that property has been created. And intellectual property is property in a very real sense – it often has real value, it can be bought and sold, it can be licensed and it can be squabbled over in the courts.

How does all this apply to you and your client? You have been commissioned by XYZ Corporation to develop a new trademark and logo for them, and this you have done. Of course, your contract with XYZ Corporation does not cover matters of intellectual property rights; it simply covers more immediate matters such as fees and timings. Some features of the laws of intellectual

property that might be relevant to this assignment include:

Q. When you have finished the job for XYZ Corporation does it own the final design? Though, the company paid you for it, but the "intellectual property" came out of your head. Whose is it?

A. This is a matter that lawyers could debate for years! In the absence of a formal agreement, the intellectual property may well reside with the designer – or it may be the client's property. However, even if, technically, you retain copyright, your client will almost certainly have exclusive rights to use the design which you have created. In order to avoid any doubt you should make it clear in your contract that all the intellectual property rights in the chosen trademark or logo will be transferred to your client.

- Q. If you did four finished designs for your client and he chose and paid for one, who owns the other three?
- A. You probably do, unless you have agreed otherwise.
- Q. You thought up a new name for your client. Is it possible to check if it is being used?

 A. Almost every country in the world maintains registers of trademarks and corporate names. Some countries, the UK and the US included in certain circumstances also allow individuals or companies to have rights in the

names they are using even without registration; these are often known as "common law" rights. It would be foolish to work on a name unless you and your client have instructed checks to be carried out to insure that the chosen name is available and not previously taken by someone else. By international agreement, trademark registers are organized by product or service classes, and you should ensure that the relevant class or classes are checked.

Q. Is it possible to check that a logo is not already in use by someone else?

A. This is a much fuzzier area of the law altogether. If I register the name Ship in the UK as a trademark for a soft drink, I have a monopoly of that name for soft drinks in that country, provided I use it in trade and otherwise keep my registration in good repair – i.e., provided I ensure that my registration is renewed as required and that infringers are stopped. If, on the other hand, I register for soft drinks a logo of an Elizabethan sailing ship as a trademark for a soft drink in the UK, I have a monopoly only in that particular design and can only stop other designs that are confusingly similar. I could probably not prevent a third party the use on soft drinks of a logo incorporating a passenger ship or a warship or a long-ship, probably not even of a 19thcentury sailing ship as my registered rights would be restricted to my particular design of an Elizabethan sailing ship. Trademarks consisting of a device have therefore much more limited protection than trademarks consisting of a name or word. You are less likely, therefore, to run the risk of infringing someone's existing rights but, conversely, your rights in your particular design will be quite limited.

Q. Should you keep your original drawings? A. Yes! Keep them all, dated and signed, or give them to your client. They can be invaluable. Recently, for example, Jordache Jeans was able to prove emphatically that the stallion's head device used on its garments was its own design and no one else's. It did this through the production of the original drawings and thereby won a major infringement case in Venezuela.

What then are the laws governing "intellectual property"? Broadly, there are four main types of intellectual property:

- Patents protect inventions. The inventor of a novel and non-obvious idea that is capable of industrial exploitation may be rewarded with a monopoly on that invention, normally for up to 20 years.
- Registered designs are to do with the features of shape, pattern, configuration and ornamentation of a useful article for example, the distinctive shape of a piece of furniture, the pattern or motif on a set of crockery or the visual appeal of a woven fabric or of a wallpaper.

Such designs can normally be protected for up to three consecutive 5-year periods.

- Copyright applies to artistic, literary, dramatic and musical works. Except in the US, you do not need to register copyright; it exists as soon as the "product" comes out of the end of your pen or brush. However, in order to enforce your rights you have to be able to prove that these rights do in fact exist and that they have been infringed. Copyright protection generally extends from the time the work is created to 50 years after the death of the author or originator.
- Trademarks are words or symbols that are used to distinguish the products or services of one manufacturer or supplier from those of another. By registering a trademark, a supplier can obtain, in that country, a monopoly of his trademark in relation to specified goods or services. The period of this monopoly can be unlimited, provided the registration is properly maintained.

By way of example, Kodak is a trademark of Eastman-Kodak Corporation. The name is protected internationally by trademark registration. No doubt certain of the machines used in the manufacture of Kodak film are protected by patents. Certain features of the design of the product or of its packaging will, undoubtedly, be protected by registered designs. The distinctive logo design, as well as being in all probability a registered trademark, will also be protected by copyright. The advertising material used in the promotion of the product, the technical manuals, original drawings, and so on will all also be protected by copyright.

As far as the designer of trademarks and logos is concerned, patents and registered designs seldom enter the picture. However, powerful and valuable rights may well exist in respect of trademarks and copyrights. Conversely, unless you are careful you may well, perhaps inadvertently, infringe other people's rights, and this can be time-consuming and costly.

What then are the cardinal legal rules to bear in mind when developing trademarks and logos? We would suggest the following:

- Sort out with your client in advance what *intellectual property* developed in the design exercise will be transferred to him and what will be retained by you.
- Ensure that any sub-contractors employed on an assignment – e.g., illustrators – pass over to you (or your client) the rights to whatever intellectual property may be developed by them.
- If you develop any new names for your client, make sure these are searched to ensure that they are available for use in all the countries and categories required.
- If you develop any distinctive trademarks for your client, either words or graphic devices, recommended to your client that these be registered in all the countries and categories of interest.
- If you have any concern at all that your new logo design may be similar to any existing designs, have a check carried out to make sure you are not infringing anyone else's rights.
- Retain, or pass to your client, signed and dated copies of all the original artwork.
- Remember that the more descriptive a word trademark, the less likely it is to be registrable and, hence, readily protectable.
- Do not misuse trademarks (see Chapter 9) or they may become seriously diluted.
- If you have any doubts, consult a lawyer, particularly a specialist trademark lawyer.

B ibliography

Advertising

Graphis Annual. Graphis Press. New edition annually.

This Business of Graphic Design. Ed Gold.
Watson-Guptill, 1985.

Art source books

Books containing a wide selection of instant camera-ready, copyright-free artwork.

Dover Pictorial Archive Books. Dover Publications.

Instant Art Library. Books 1 & 2. Graphics World, 1980.

Computer graphics

Computer Graphics for Graphic Designers. John Vince. Francis Pinter, 1985. Creative Computer Graphics. Jankel and Morton. Cambridge University Press, 1984.

The Dictionary of Computer Graphics. John Vince. Francis Pinter, 1984.

Colour

Colour and Communication. Jean-Paul Favre, Andre November. ABC Editions, 1984.

Colour Harmony. A Guide to Creative Colour Combinations. Hideaki Chijiiwa. Greenwood Press, 1987.

Designers Guide to Colour, Volumes 1 & 2. Stockton. Angus and Robertson, 1984. Theory and Use of Colour. Luigina De Grandis. Blandford Press, 1986.

Design and production

Advertising Layout Techniques: A Step-bystep Guide for Print and TV. H. Borgman.
Watson-Guptill, 1983.
Design A La Minale Tattersfield. E. BoothClibborn, editor. A retrospective of the
work of Minale Tattersfield.
The Design Concept. A. Hurlburt. An
analysis of the practical problems in
graphic design. Watson-Guptill, 1982.
The Design Dimension. Product Strategy
and the Challenge of Global Marketing.
C. Lorenz. Basil Blackwell, 1986.
The Designer's Handbook. Alastair
Campbell. Macdonald, 1983.

Index

Page numbers in italic refer to	British Airports Authority, 96,	105, 105	H
illustrations and captions	97-104	Cubic Metre, 21	hallmarks, 10, 10
	Coca-Cola, 106, 106-9	curves, 30, 31	Hapsburg eagle, 9, 9
A	Crusade Yacht Club, 105, 105		Haywards Pickles, case studies, 118,
abstract logos, 24-5, 24	Duckham's QXR, 110, 110-13	D	118-21
aesthetics, 26-37	Glade, 114, 114-16	Davis, Paul, 123	Heublin, 8
balance, 31	Haywards Pickles, 118, 118-21	Deaver, Georgia, 34	hot foil blocking, 89
colour, 35	London Chamber of	design briefs, 38-49	hue, 34
corners, 30, 31	Commerce, 117, 117	budgetary constraints, 40	
curves, 30, 31	Repsol, 122, 122	competitive constraints, 40-2	I
fashion, 32-5	Silver Screen, 123, 123	duration of use, 44	I.N.H., 122
shapes, 31-2	The "21" Club, 123, <i>123</i>	further information, 45-7	ICI, 31-2, 32
solids, 31-2	case studies (hypothetical), 63-81	gathering information, 39-45	illustration, 87-8
straight lines, 27	Antiquarius, 65-7	international use, 43-4	reference sources, 88, 88
Alitalia, 22	Beachfront Properties, 63-4	licensing plans, 44-5	implementation, 124-7
allusive logos, 22, 22	Compton Productions, 68-9	positioning constraints, 42-3	initial letter logos, 18-19, 19
Anaconda Industries, 22	Continental Coffee, 70-2	pricing constraints, 40	intellectual property, 138
anticipating future needs, 127	Telecommunications	product constraints, 40	international use, 43-4
Antiquarius, case studies, 65-7	Company, 78–81	promotional plans, 44	
applying the design, 124-7	Torq Computer Systems, 49,	range extension, 44	I
associative logos, 21, 21	50-62	typical example, 49	John Deere, 132
associative names, 137	Vista, 73–7	visualizing, 50-5	Johnson Wax, 114, 114-16
Avante Garde, 29	City Investing, 24	writing, 47-8	Jordache Jeans, 139
Availle Garde, 29	Coca-Cola, 6, 31, 32, 126	designers, 15	<i>J</i> ,
В	case studies, 106, 106-9	device marks, 6	K
	Coley Porter Bell, 117, 117	die-stamping, 89	Kodak, 137
B.A.A., case studies, 96, 96-104	colour, 35	distinctiveness, 15	Kuwait Petroleum, 124, 125
balance, 31 Balmoral, 29	specifying, 85-7	Duckham's QXR, case studies, 110,	Transaction of the state of the
	colour wheel, 34	110-13	L
Bass, 11 Beachfront Properties, case studies,		duration of use, 44	lamination, 90
63-4	composite marks, 6	duration of doc, 11	Landor Associates, 106, 106-9
Benz, 131	Compton Productions, case	E	layout, 82-4
Bitter Lemon, 137	studies, 68-9	engraving, 89	legal aspects, 138-40
	computer graphics, 53, 53	Exxon, 137	copyright, 138, 140
blind embossing, 89 borders, <i>30</i>	Concorde, 26	Zinton, 157	intellectual property, 138,
Bovis, 87	constraints:	F	139-40
Brace Condensed, 123	budgetary, 40	fashion, 32-5	names, 138-9
brand names:	competitive, 40-2	Festival of Britain, 12	original drawings, 139
developing, 134-7	duration of use, 44	Fisher, Roger, 117	patents, 139
legal searching, 136	international use, 43-4	Fitch & Company, 114, 114-16	registered designs, 139-40
maintaining rights in, 133	licensing plans, 44-5	fleur-de-lis, 9, 9	registering names, 139
selecting names, 134-6	positioning, 42–3	flexibility, 126, 127	trademarks, 140
	pricing, 40	Formica, 137	legal rights, maintaining, 133
spectrum, 136-7	product, 40	franchising, 44	legal search, brand names, 136,
British Airports Authority (B.A.A.) case studies, 96, 96-104	promotional plans, 44	Franklin Gothic Condensed, 28	138-9
British Airways, 125	range extension, 44	Franklyn, Mervyn, 87	Leonardo da Vinci, 38
Brooke Bond Oxo, 118	Continental Coffee, case studies,	future needs, 127	letterheads, 57, 57, 82, 83
	70-2	ratare needs, 127	Levi, 18
budgetary constraints, 40	copyright, 138	G	libraries, reference, 94-5
C	corners, 30, 31	Garamond Light Italic, 28	licensing plans, 44-5
	corporate identity:	Glade, case studies, 114, 114-16	logos:
Cagney, William, 24	manuals, 125	Grand Metropolitan, 8	aesthetics, 26-37
Camel, <i>13</i> camera-ready artwork, 91	programs, 124-7	The Graphic Workshop, 83	definition, 6-8
Cariba, 42	creators, 15	Gray, Linda, 87	distinctiveness, 15
case studies (actual), 96-123	Crusade Yacht Club, case studies,	512 _j , 2111311, 57	history, 9-10
case secures (actuar), 70-123	States Author State, case states,		,

importance of, 10-12 pricing constraints, 40 mechanicals, 91-2 printing processes, 88-91, 93 Waverly, 90 legal aspects, 138-9 paper, 91 maintaining the design, 127-30 blind embossing, 89 presentation, 92-4 Westinghouse Electric, 130 need for stability, 14-15 pricing, 94 Whittle, Sir Frank, 38 die-stamping, 89 engraving, 89 hot foil blocking, 89 printing, 88-91, 93 Wool, 22 role of the designer, 15 types of, 16-25 reference sources, 88, 88, 94-5 word marks, 6 specifying colour, 85-7 up-dating designs, 130-3 lamination, 90 London Black and White spot varnishing, 90 typography, 84-5 Zeta Matt Post, 90 Company, 86 thermography, 89 Telecommunications Company, London Chamber of Commerce, ultraviolet varnishing, 90 case studies, 78-81 thermography, 89 varnishing, 90 promotional plans, 44 case studies, 117, 117 Thumb Design, 34 Lubalin Graph Bold, 29 puns, 21 TM symbols, 133 M Torq Computer Systems, 50-62 maintaining the design, 127-30 abacus solution, 52-3, 53, 58-9, Q8, 124, 125 manuals, corporate identity, 125 Quaker Oats, 11 market research, 46-8, 46 computer solution, 53, 53, 59, brand names, 135 qualitative market research, 47 materials, 91 quantitative market research, 47 design brief, 49 line solution, 52-3, 52, 53, 55-7, paper, 91 questionnaires, 46, 46 mechanicals, 91-2 Quintess Antiques, 33 QXR, 110, 110-13 T in a circle solution, 55, 55, 60, menus, 84 Mercedes, 22, 22, 131 visualizing the brief, 50-6 Middle Ages, logos, 9 Miles, Robert, 24 R symbols, 133 trademarks: range extension, 44 aesthetics, 26-37 Mitsubishi, 45 reference sources, 88, 88, 94-5 Moss Bros, 13 definition, 6-8 registering names, 139 distinctiveness, 15 Repsol, case studies, 122, 122 history, 9-10 name-only logos, 16-17, 16, 17 researchers, 15 importance of, 10-12 name/symbol logos, 18, 18 legal aspects, 138-9 rights, maintaining, 133 maintaining the design, 127-30 Rolls Royce, 6 names: developing, 134-7 need for stability, 14-15 legal aspects, 138-9 registering, 139 legal searching, 136, 138-9 Schweppes, 137 role of the designer, 15 types of 16-25 shapes, 31-2 maintaining rights in, 133 Shell Oil, 21, 129 selecting, 134-6 up-dating designs, 130-3 Siebert/Head, 110, 110-13 spectrum of, 136-7 Transax, 27, 27 The "21" Club, case studies, 123, Nike, 18 Silver Screen, case studies, 123, 123 SM symbols, 133 Smirnoff, 8, 8 typefaces, 27 Olins, Wolff, 122, 122 Smith & Milton, 118 typography, 84-5 original drawings, 139 solids, 31-2 originality, 38 spot varnishing, 90 straight lines, 27 ultraviolet varnishing, 90 Unilever, 118 strategist, 15 PANTONE® Matching System, 86, Sunsilk, 137 United Nations, 8 up-dating designs, 130-3 Sweet 'n' Low, 137 ÚSEMCÖ, 24 paper, 91 Pentagram, New York, 123, 123 perseverance, 95 Tayburn Design, 105, 105 Philips, 22 techniques: varnishing, 90 illustration, 87-8 VISA, 137 pictorial name logos, 20, 20

Vista, case studies, 73-7

layout, 82-4

materials, 91

presentation, 92-3

pricing, 94

Acknowledgements

Apple Computers; Bass Museum of Brewing; Sandra Laird and David Bromige of BDFS; Trustees of the British Museum; Camera Press; Charlotte Borger and Jan Hall of Coley Porter Bell; Annette Stover of Creative Centering; Courtauld Institute Galleries; Georgia Deaver; E.T. Archive; European Colin Wiltshire of Fitch & Co; Sue Ridley of Interbrand; Kores Nordic Ltd; Jane Stevenson and Kip Reynolds of Landor Associates; Jim Northover of Lloyd Northover; Janet Fogg of Markforce Associates; Meissen; Mitsubishi; Pam Broom of Minale Tattersfield; NASA; Tom Blackett of Novamark International; martin Butler of Opera Photographic Ltd; Phyllis Scheck of Pentagram, NY; Private Eye; Mr Lewis Gaze of Rolls Royce Motors; Safeways; Michael Selway of Sampson Tyrrell; Isabel Philips of Siebert Head;

Tracy Green of Signia Design; Jeremy Haines and Pippa Martlew of Smith and Milton; Daniel Ruesch of Tandem Studios; Dick Davis of Tayburn Design; Dr Jeremy Phillips, editor of *Trademark World*; United Nations; Victoria and Albert Museum; Derek Halfpenny of Josiah Wedgwood & Sons Ltd; Brian Boylan and Ian Hay of Wolff Olins.